	DATE DUE	
SEP 2 8 2012		

Succeed in

Landscape Photography

Mark Lucock

This book is dedicated to Rebecca

Published and distributed by RotoVision SA
Route Suisse 9
CH-1295 Mies
Switzerland

A RotoVision Book
RotoVision SA
Sales & Editorial Office
Sheridan House
112/116A Western Road
Hove
BN3 1DD
UK

Tel: +44 (0)1273 72 72 68
Fax: +44 (0)1273 72 72 69
Email: sales@rotovision.com
Web: www.rotovision.com

10 9 8 7 6 5 4 3 2 1

ISBN: 2-88046-792-6

Design by **Balley Design Associates**
Art direction by **Luke Herriott**

Reprographics in Singapore by ProVision Pte. Ltd
Tel: +65 6334 7720
Fax: +65 6334 7721

Printing and binding in Singapore by ProVision Pte. Ltd

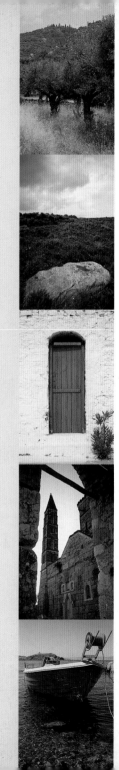

Contents

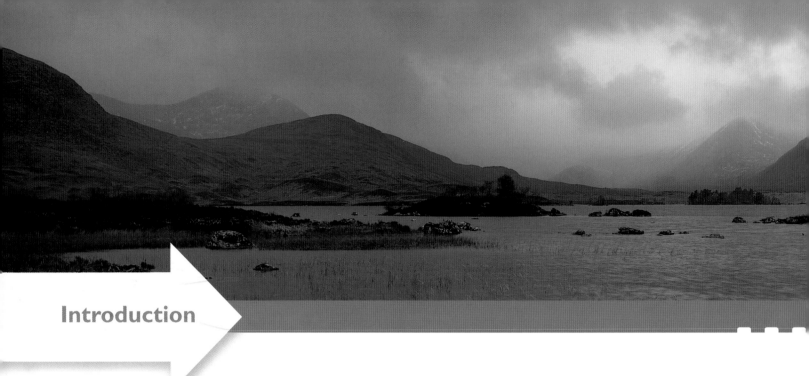

Introduction

below ➤ **Mexican Hat, near the Utah/ Arizona border is unusual. I was just passing through, so I couldn't spend time to do it justice but it certainly merits a couple of frames. Pentax 35mm on Velvia, using the car as a tripod.**

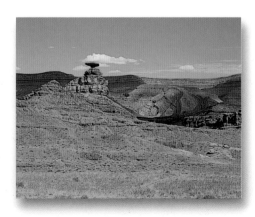

From fine art to money spinner

Among the great North American landscape photographers, no-one is more revered than the late Ansel Adams. His images of the American wilderness captivated the national imagination, and inspired many to follow in his footsteps.

Today, with improved equipment and sharp color emulsions such as Fuji Velvia and Kodak Ektachrome E100VS, another generation of talented landscape photographers are continuing Adams' legacy. Look out for David Muench, Tom Till, William Neill, and Jack Dykinga, all of whom produce beautiful large-format photographic art that is helping to keep the spirit of our landscapes alive.

The power of a beautiful image should never be underestimated. Photography can offer far more to landscape lovers than a means to produce high-quality, commercially viable images.

For me, the anticipation of a photographic trip out to a beautiful part of the countryside is a wonderful thing. This state of euphoria continues until I pick up my transparencies from the lab. My freshly processed E6 slides provide a gratification that is hard to express in words.

Learning through photography

You will find that when you eventually get bitten by the bug, landscape photography changes the way you do and see things. Your travels will start to have more focus—you will gravitate toward the best vistas at the best times of the year, as well as at the best times of day. You will gradually find you notice details in a scene that once were invisible to you. You will develop empathy for the landscape and its component parts. You will learn to read the weather, so as to search out the best light.

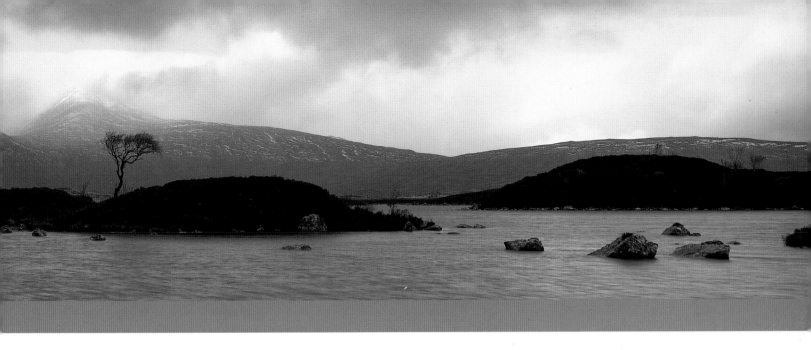

You do not have to be a trained artist to take beautiful images of the landscape; you just need to develop your eye for a good picture. Technical prowess, passion, drive, and a positive outlook all help, and conspire to separate the keen amateur from the successful professional. Where you fall is not relevant—all that matters is that you enjoy yourself. I wish you well in all your photographic endeavors. Who knows, you may become the next Ansel Adams, and have some of your prints fetching in the region of $100,000 each. Food for thought?

above ➤ **Rannoch Moor, Scotland. I only got one acceptable image out of a whole batch. Fuji GX617 + 90mm lens on Velvia.**

below ➤ **The buttress root system of a majestic rainforest tree. Mamiya 7II + 43mm lens on Velvia, 8sec tripod.**

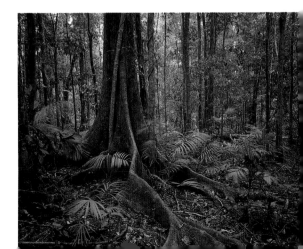

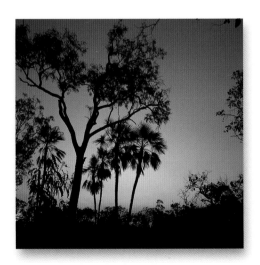

above ➤ **Kakadu, Australia. Silhouettes always look good at sunset. Mamiya 7II + 43mm lens.**

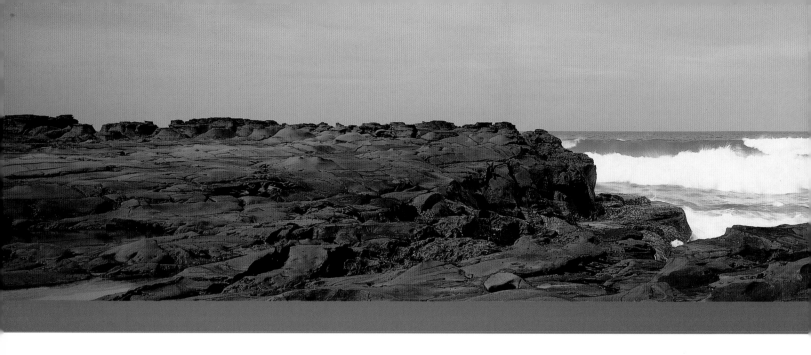

below ➤ **The 6x12cm slide covers only the waterfall, and makes this the sole feature of the picture.**

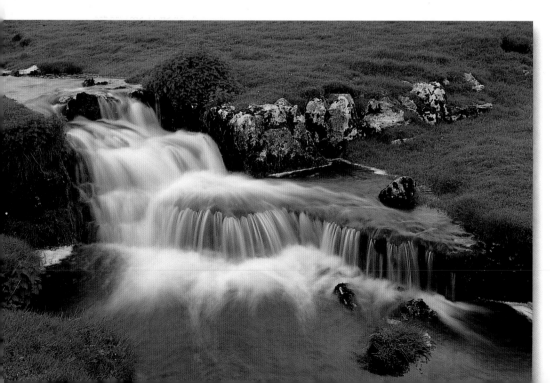

Creative landscape photography

As a walker, I love to absorb the landscape. However, it is only in my role as a photographer that I am able to satisfy all facets of my character. The camera provides me with the best way to express information about the landscape.

To succeed as a photographer specializing in creating fine-art images of the landscape, it is not enough to love the great outdoors. Nor is it sufficient to possess technical know-how about cameras. You need both, but above all else you need a passion for the process. Armed with an eye for a picture and technical prowess, dull pictures become a thing of the past. You become a maker, rather than a taker, of pictures. Most people go out with their auto-everything camera, see a nice view, point and shoot. This is taking a picture. To make a picture takes far more effort. I recently traveled a couple of hundred miles

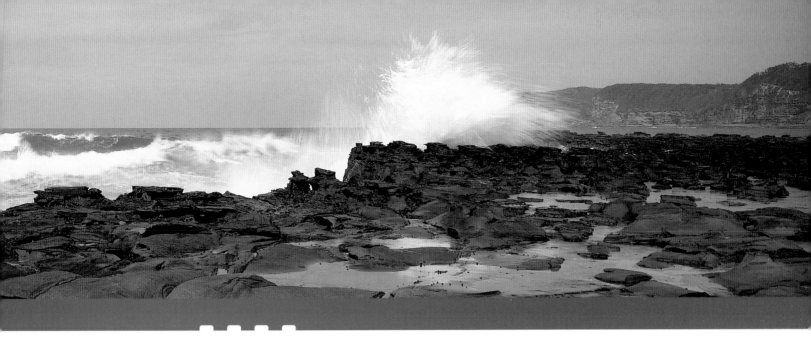

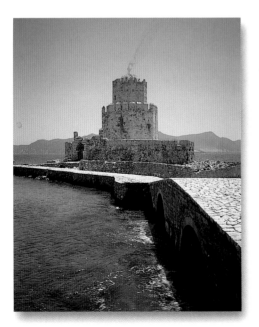

above ➤ **North Avoca Beach, NSW, Australia. Beach scenes suit all camera formats, and are easy subjects for panoramic photography. FujiGX617 + 90mm lens on Velvia.**

left ➤ **Octagonal Ottoman Fort, Methoni, Greece. The composition leads the viewer diagonally across the frame. Emphatic diagonal lines always work well. F/22 at 1/10sec on Velvia.**

to shoot a fishing village. The process was extremely labored. I spent two hours "making" one good 5x4in image. Even then, the Velvia transparency needed a couple of seagulls cloning out before I printed the final image. Clearly, there is a world of difference between taking and making images. Successful creative shots need forethought. It is not hard to see why a razor-sharp 4- or 5ft (1.5m) landscape print from a large-format sheet of Velvia can command hundreds of dollars. It may only take half a second at f/32 to expose the film, but a lot more than pressing the shutter is involved in making a highly saleable fine-art print.

This book is designed to help everyone who loves the landscape achieve the best images possible with the optical and post-exposure digital technology that is available today. Where technical details were recorded, these are given in the image captions. The main aim of this book is to encourage you to improve your work to a very high standard, to learn how to give it the best exposure—and to make money from it to whatever level you want.

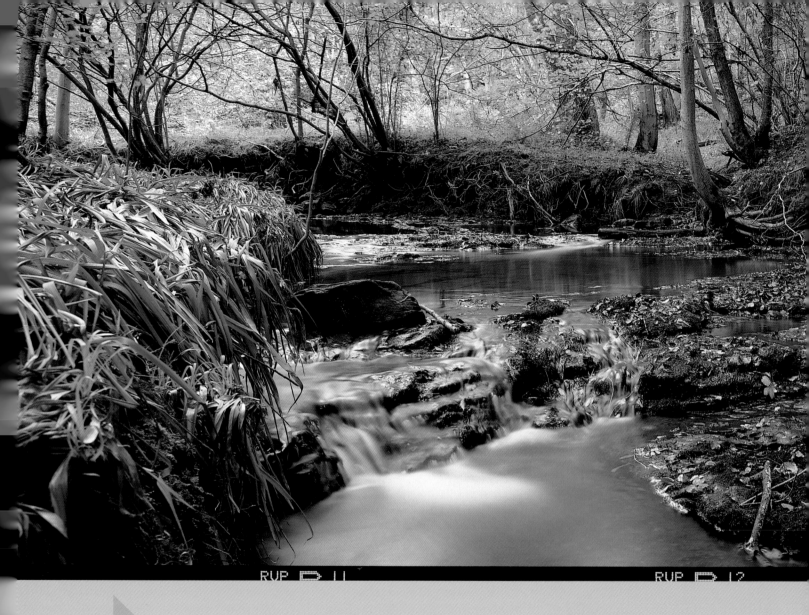

RVP ▷ 11 RVP ▷ 12

Getting started

8A 9 ➡️ 9A

RUP ▷ 13 RUP ▷ 14

starts with an outline vision. „

Getting started

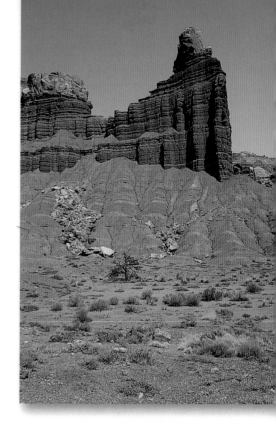

Choosing the right equipment

There is a general belief that the slower and more difficult the photographic process becomes, the more the photographer thinks about the composition, and the better is the final result. I think this is true; your photography generally improves as you move from 35mm up to medium format, since using a tripod and a hand-held meter slows things down considerably. The medium-format photographer has to make more time for a shot and is likely to be more attentive to the final composition. This process jumps by an order of magnitude in large-format photography. In fact, you are unlikely to use large-format unless you already have an outline vision of the final image, so great is the investment in time for this brand of photography. Also, the larger the format, the greater the final print enlargement can be. Thus, an increase in the thought process, along with improved image quality, makes medium- and large-format cameras the favored instruments of the creative landscape photographer. But they certainly do not have to be exclusively used. One can use 35mm cameras—even compacts—to good effect.

The following section looks at the tools that enable you to make truly creative photographs. SLR cameras are the most versatile tools available for editorial nature photography, but this field primarily involves cameras that can produce really big images—with supreme sharpness. Not everyone needs to go this far, and so all camera types and formats get a mention.

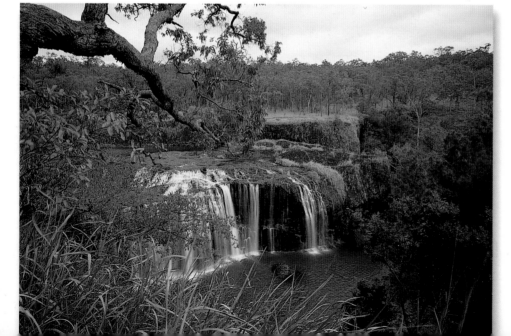

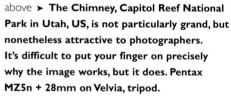

above ➤ **The Chimney, Capitol Reef National Park in Utah, US, is not particularly grand, but nonetheless attractive to photographers. It's difficult to put your finger on precisely why the image works, but it does. Pentax MZ5n + 28mm on Velvia, tripod.**

left ➤ **Millstream Falls, Queensland, Australia, during the dry season. I used a eucalyptus branch in the foreground to lead the viewer into the frame and included tall grass at the cliff to add further interest. A cloudy sky produced low contrast, which I like. The use of an ultra-wide lens helped keep near–to–far sharpness. Mamiya 711 + 43mm lens on Velvia.**

35mm compact cameras

How many times have you been in a special place, or an ordinary place at a special time, and thought to yourself, "If only I had brought my camera with me?"

I am a committed photographer with a passion for travel. But sometimes I have found myself without a camera just when I wanted to record sunsets, cultural events, or exotic animals and plants because I could not be bothered to carry my equipment out with me. More often than not, I will drag a medium- or large-format camera and tripod around all day, often in hot and humid conditions, with prospective shots in mind. After finishing up, there will inevitably be the most magnificent sunset: fiery red with streaks of vermilion. Can I enjoy this magical view? No way! All I can do is berate myself for leaving my camera in the hotel room.

You need to be prepared for the unexpected. A few years ago I realized that one of the best ways to be always at the ready was to carry a compact camera with me. Far from being an amateur's toy, today's legion of compact cameras embrace technology that can satisfy the most discerning of professionals.

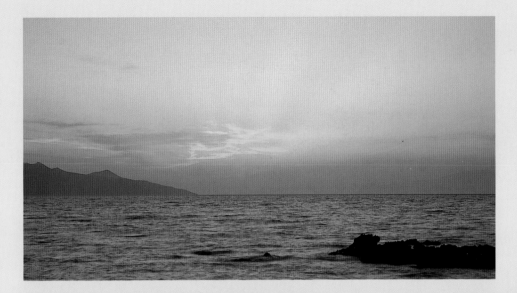

above ➤ **Sunset over the Gulf of Messenia, Greece. Fuji GA 645Zi, Velvia, f/22 at 1sec (no exposure adjustment).**

right ➤ **Aghios Dimitrios, Greece, taken impromptu with a compact camera. Fishing boats in a small harbor are always photogenic.**

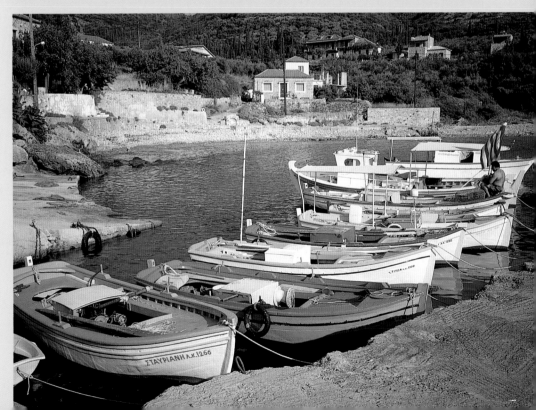

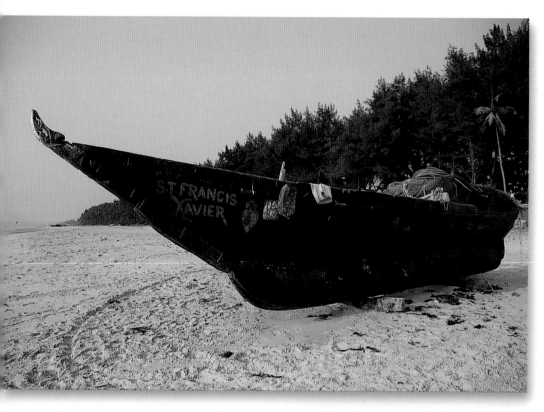

The most diverse range of equipment belongs to the 35mm compact market. At any one time, there are almost three times as many compact cameras available as there are 35mm SLRs. This is the sharp end of the photographic market place and the turnover of models is rapid. This means that the consumer has a good choice at a reasonable price.

Pros and cons

35mm compacts are simple to operate— "point and shoot" technology means you should never miss a photographic opportunity again. Extreme compactness means that you have no excuse not to carry the camera at all times. The pros and cons are obvious: on the plus side they are cheap, light, and portable—ideal for landscape pictures. Top-of-the-range models have sharp optics, and enough features (i.e. flash, good zoom range, splash-proofness) to make them highly versatile tools. With compacts, simplicity of use allows you to concentrate on the subject, rather than on technicalities.

above ➤ **Fishing boat, India. Handheld Pentax SLR on Velvia.**

right ➤ **This stone structure could have any number of purposes. Whatever it is, it sits perfectly against the olive tree in a classic rustic Mediterranean vista. Fuji GA645Zi on Velvia, f/19 at 2sec.**

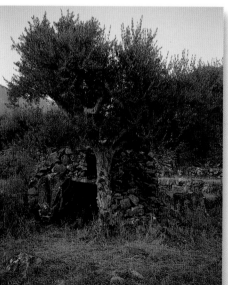

right ➤ **This image was taken early in the morning using front tilt. I didn't need to use a polarizer, as the sun was low and highly directional. This shot was one of a bracketed set. I used a graycard to meter from, which gave about two-thirds of a stop overexposure. A mid-toned area of cliff gave about two-thirds of a stop underexposure. This was the frame in between the two. Ebony RSW + 80mm Schneider Super-Symmar lens.**

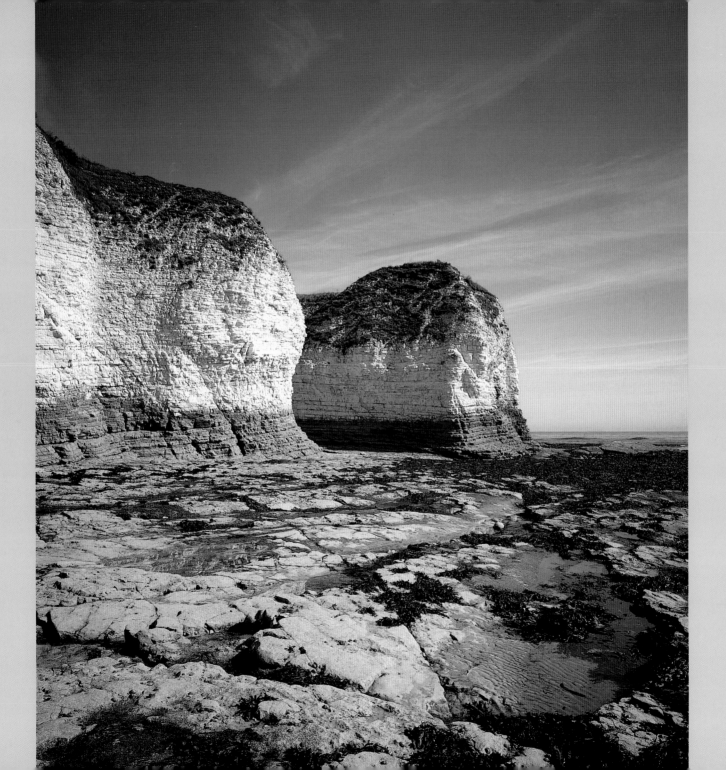

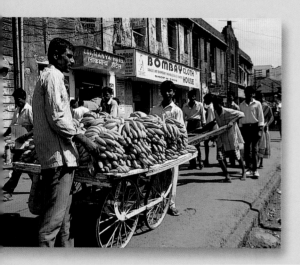

On the minus side, they generally give poor results for close-up and distant subjects (not such an issue in landscape work). With notable exceptions, it is almost impossible to manipulate exposure. Not that it means too much in the real world, but under rigorous conditions results won't compare with those from a 35mm SLR.

Limitations

Perhaps the greatest drawback of a compact compared to an SLR is the fact that you cannot change lenses. There are also few accessories available for compacts. With an SLR camera, you view your subject through the lens, while a compact has separate viewfinder and lens. This creates "parallax" in compacts, particularly when working at close range. The upshot is that what you see is not always what you get.

My first serious compact was a splash-proof Yashica T3, and while it had a fixed 35mm lens, it was a sharp Carl Zeiss T star design. I then moved on to a Pentax 90WR, again waterproof. I liked the level of control and the 38–90mm zoom lens. My current 35mm compact camera is the Ricoh GR1v. This camera is minute, has a razor-sharp aspheric 28mm lens, and is 100 percent controllable (point of focus and f-stop can be set manually for complete exposure and focus control). I also like the fact that you can make long exposures—although you need

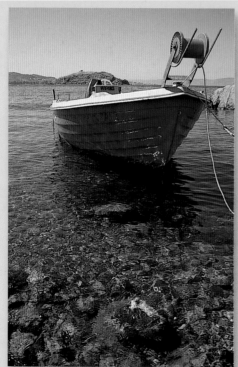

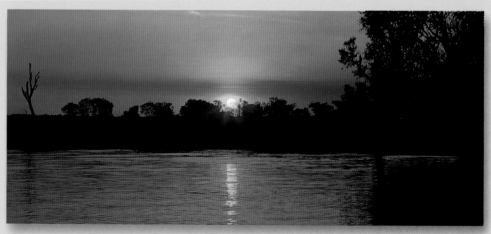

above ➤ **Billabong at dusk. I love the way light, birds, and the water conspire to produce a magnetic image. Pentax MZ5n + 28–70mm zoom on Velvia.**

above left ➤ **Banana sellers in India. Handheld Pentax SLR on Velvia.**

left ➤ **Fishing boat off the island of Lesbos, Greece. Using a wide-angle lens (28mm) permits an all-encompassing perspective, from crystal clear waters at the sea edge to a more distant coast and sea vista. Handheld Pentax LX + 28mm lens.**

a separate meter. This compact is small, easy to use, and ideal as a second camera to augment your larger-format kit.

I love wide-angle lenses; the 28mm design on my Ricoh is perfect for all types of landscape and environmental imagery. But the equivalent of a 28mm lens is not always enough, and lenses around 20mm (35mm-format equivalence) provide tremendously sharp foreground interest.

Choose a compact camera that allows you to use ISO 50 film, so that you can benefit from Fuji Velvia. Most people can hand-hold a small, lightweight compact under fairly low light conditions, and, even with slow ISO 50 film, achieve really sharp landscape shots.

right ➤ **Whenever I have the opportunity, I look for intimate perspectives on coastal landscapes, scenes that allow me to emphasize the foreground as a critical part of the view. Here, the island in the distance had an ancient ruin that caught my attention, but it was too far away to be the subject of the picture. I needed to make it a secondary element with the foreground rocks taking precedence to make a picture that was both attractive and interesting. GA645Zi on Velvia, f/22.**

35mm SLRs

For many people, the 35mm camera is the entry point into the world of landscape photography. It is extremely accessible, economic, and versatile.

Pros and cons

The 35mm film frame covers an area of 24x36mm. This is diminutive compared to a sheet of 5x4in film, but with today's high-resolution films it is quite adequate for tack-sharp prints 8 × 12in (20x30cm) or larger. It is perfect for smaller editorial reproduction in magazines and books, making it the mainstay of the jobbing photojournalist, and it is also widely used for fine-art and landscape photography. The qualities of modern 35mm film emulsions with a fine grain (or low "Root Mean Square" [RMS] value) allow sharp reproduction for both publications and moderately sized gallery prints. For transparency film, the RMS value for Velvia is 9 (about as low as it gets for non-print film). So with a 35mm SLR, high-resolution film, quality optics, and a tripod, I can shoot evocative landscapes.

The 35mm SLR is ideal for social–documentary style photography and candid moments. The vast selection of lenses, particularly "long toms," makes it ideal for shooting fast-moving sports action and wildlife. At the other end of the spectrum, extreme wide-angle lenses are ideal for interesting perspectives. Many well-known landscape photographers have made a name for themselves with the innovative use of 35mm—including the late Galen Rowell.

What makes the SLR so popular is the level of technical sophistication in even the cheapest of models. Sophisticated metering systems are difficult to fool, even in tricky lighting conditions. Flash systems are now generally controlled by sensors near the film plane, which means that flash light can be applied with the same fool-proof exposure accuracy that regular ambient light metering permits. With such "through the lens" (TTL) metering options, you can guarantee good results. Autofocus lenses augment an accurate exposure capability with sharp focus. The fidelity of the 35mm image has been improved even further in recent years, with the inclusion of aspheric lens technology producing razor-sharp optics at a reasonable price. In fact, the level of technical sophistication in today's 35mm SLRs means that you can forget the technicalities of taking a picture, and concentrate on the composition and natural lighting.

Really, there are few drawbacks to the 35mm SLR camera. It is only when you want to shoot with immaculate sharpness and top quality that you might need to consider a larger format.

"Many well-known landscape photographers

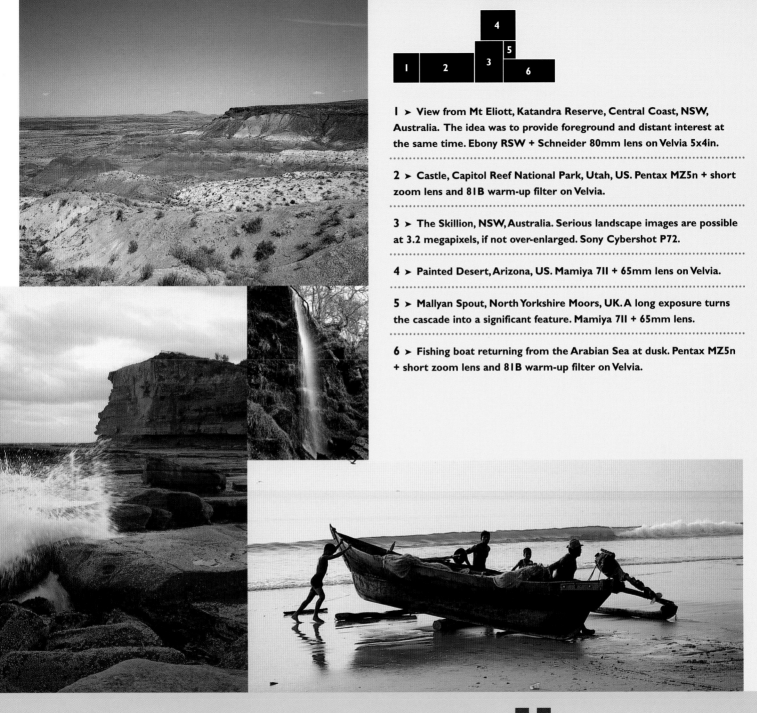

1 ➤ View from Mt Eliott, Katandra Reserve, Central Coast, NSW, Australia. The idea was to provide foreground and distant interest at the same time. Ebony RSW + Schneider 80mm lens on Velvia 5x4in.

2 ➤ Castle, Capitol Reef National Park, Utah, US. Pentax MZ5n + short zoom lens and 81B warm-up filter on Velvia.

3 ➤ The Skillion, NSW, Australia. Serious landscape images are possible at 3.2 megapixels, if not over-enlarged. Sony Cybershot P72.

4 ➤ Painted Desert, Arizona, US. Mamiya 7II + 65mm lens on Velvia.

5 ➤ Mallyan Spout, North Yorkshire Moors, UK. A long exposure turns the cascade into a significant feature. Mamiya 7II + 65mm lens.

6 ➤ Fishing boat returning from the Arabian Sea at dusk. Pentax MZ5n + short zoom lens and 81B warm-up filter on Velvia.

have made a name with the innovative use of 35mm. "

Medium-format cameras

Many photographers move up to medium format because they want to produce better enlargements, and they have heard about the potential for much bigger, sharper prints to be made from 120 roll film transparencies. Additionally, many markets—particularly the fine art market—will only consider medium- or large-format images when submitted for consideration.

Medium-format equipment represents a mixed bag of camera types compared to the 35mm genre. They might all employ 120/220 roll film, but the amount of this roll film format that can be exposed varies. You need to decide what roll film aspect ratio you prefer for your landscape compositions. The current choice is between 6x4.5cm, 6x6cm, 6x7cm, 6x8cm, 6x9cm, and three panoramic formats: 6x12cm, 6x17cm, and 6x24cm.

With the exception of a few virtual "point and shoot" 6 x 4.5cm models, the size of these cameras necessitates a tripod, which introduces a more considered approach to your photography, helping you to develop rigor in image composition and timing. This extension of the thought process definitely helps produce better pictures, as does the fact that, for any given reproduction size, medium-format transparencies are more forgiving than 35mm format.

I tend to examine my viewfinder more carefully when I have my camera set up on a tripod than when I am shooting hand-held. And the more elaborate photographic procedure associated with using my heavy Mamiya 6x7cm or Fuji 6x9cm rangefinder cameras means I am much more reliant upon my own thought processes to get things right. If you make such an investment in thought and effort, it demands good results.

left ➤ **Coastline images are always popular. I prefer rocky coasts for photography. This one was full of tidal pools, each of which maintained its own marine microcosm in between the tidal flux. The light was bright and the rocks were dark so I bracketed quite extensively. GA645Zi, Velvia, f/22 at 5sec.**

below ➤ **This termite mound and stratified rocks look just like a ruined building. At dusk the starkness of the day is lost, although you still need to worry about long shadows. Mamiya 711 + 43mm lens.**

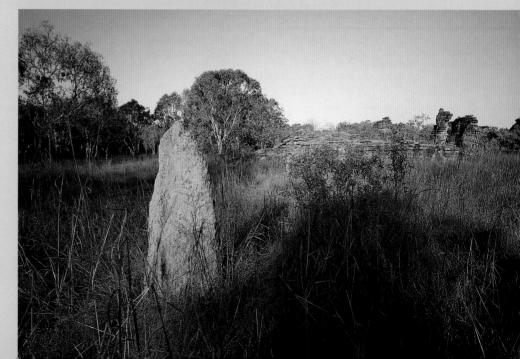

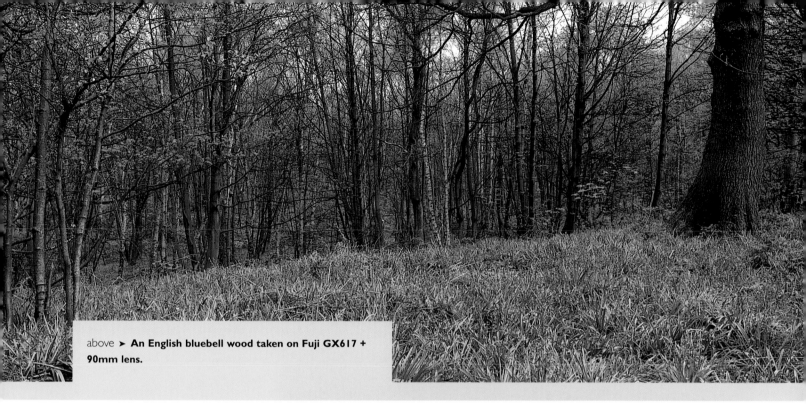

above ➤ **An English bluebell wood taken on Fuji GX617 + 90mm lens.**

Which roll film aspect ratio?

A medium-format transparency requires less magnification than a 35mm slide for a given reproduction size; it also provides more impact when viewed next to a 35mm slide on a lightbox. Medium-format landscapes have more potential for sales, and for making large gallery prints. But what aspect ratio best suits landscape is not easy to answer. The nominal dimensions of medium-format camera systems are in fact slightly larger than the film that is exposed by them. The following table illustrates the exposed area for a nominal film format size.

Nominal format size	Actual format size	Actual exposed area (mm²)
35mm	3.6 x 2.4cm	864
6x4.5cm	5.6 x 4.2cm	2352
6x6cm	5.6 x 5.6cm	3136
6x7cm	5.6 x 6.95cm	3892
6x8cm	5.6 x 7.6cm	4256
6x9cm	5.6 x 8.4cm	4704

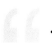 ...medium-format landscapes have more potential for sales... "

A quick calculation shows that a 6x4.5cm frame from the smallest medium-format aspect ratio yields an image 2.72x the size of a 35mm frame, while a 6x7cm slide is 4.50x the size of its 35mm counterpart. A 6x9cm slide is 5.44x the size of 35mm film, and roughly half the size of both a sheet of 5x4in large-format film, and a 6x17cm panoramic roll film frame.

Size per se is not the only consideration when selecting the film format. You need to consider how the final image is going to be cropped. For a fairly standard 8x10in (20x25cm) magazine page, one wouldn't need to crop a 6x7cm slide at all, but the 6x4.5cm aspect ratio requires a loss of nearly six percent of the image area. To fill the same page size, a 35mm image would need

17 percent of the original image cropping out— the loss would be substantial. The compatibility of individual aspect ratios with the typical magazine page is why so many photographers and editors refer to the 6x7cm aspect ratio as the "golden format." Despite this, most medium-format slides shot in the "golden" 6x7cm aspect ratio are still cropped to fit into a page layout, which can

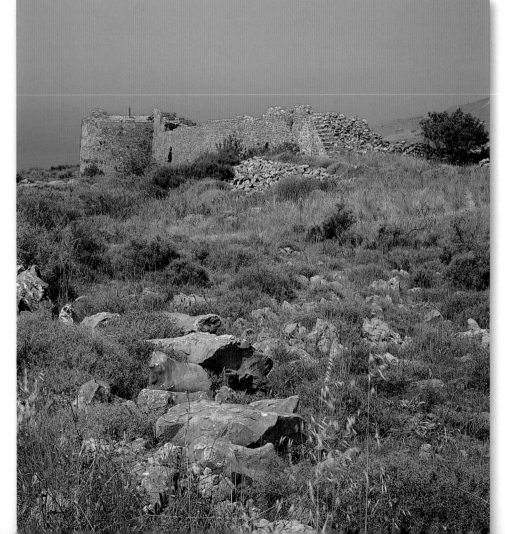

left ➤ **Ottoman Castle at Kelefa, Mani, Greece. This picture emphasizes the foreground scattering of rocks that lead to the imposing ruins. The sun provided natural warmth. GA645Zi, Velvia, f/27 at ¹/₁₅ sec.**

below ➤ **I used the geometric lines on the pavement to lead the eye up to this Greek village house. Fuji GA645Zi.**

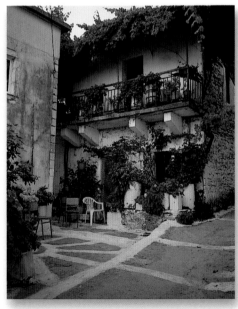

undermine the original composition, so I don't think it is a big deal to opt for one format over another. Indeed, proponents of the 6x6cm aspect ratio argue that they are free to compose their views without worrying about editorial cropping.

Before deciding which aspect ratio might suit you best, consider which orientation you prefer to shoot—landscape or portrait? I prefer the 6x7cm (and similar 5x4in) aspect ratio above the more stretched 35mm–like medium-format ratios. For me, the 6x7cm aspect ratio in portrait orientation is like a perfect door on the world. Foreground detail and sky seem to fall into place with the minimum of conflict.

There are many excellent medium-format camera systems to choose from, and they are not quickly superseded, unlike their 35mm counterparts. Take your time, and pick the model that best fits your objectives and style.

above ➤ **North Yorkshire Moors National Park, UK. My favorite use of the 6x17cm panoramic format is to capture intimate landscapes that draw the viewer into the scene, or, when printed up big, bring the scene right into the viewer's home. This transparency is one of my favorites, and was taken almost on my own doorstep. I spent many hours and exposed 13 rolls of film, but I think the effort and cost are worth it, when you see great results as large gallery prints. Velvia, exposures in the region of 45 seconds at f/32.**

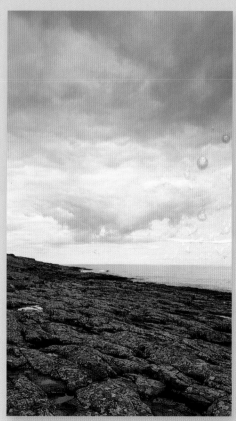

right ➤ **A 0.6ND grad was used to shoot this coastline in vertical panoramic orientation using a 6x12cm back on an Ebony RSW + 75mm Rodenstock. I left the concentric ND grad matched to the 75mm lens in place and simply held the Lee 0.6ND grad in front of it. I took care to keep my fingers clear.**

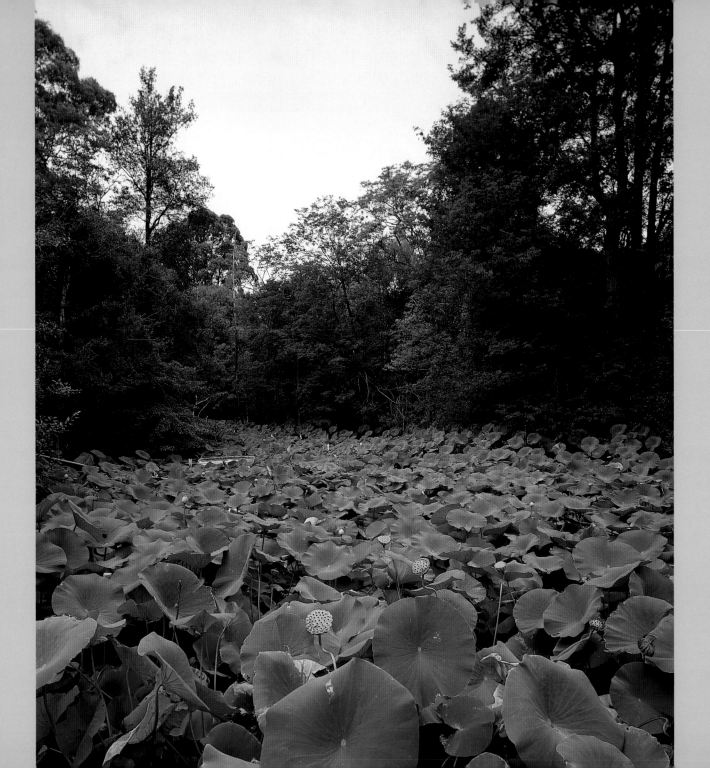

Features of the medium format

I prefer a system that is lightweight, has razor-sharp interchangeable lenses, and permits aperture-priority autoexposure down to several seconds. It should also have the largest possible coverage on 120 roll film. With these criteria in mind, I like the Mamiya 7II rangefinder system, which has become my bread-and-butter medium-format camera. The lenses that I have for it are tack-sharp. The one other contender is the Pentax 67II. While the Mamiya is very lightweight and ideal for long hikes, the bulkier Pentax goes down to an autoexposure of 30sec. The Mamiya goes down to 4sec on autoexposure—anything beyond this gets metered with a spot attachment on a hand-held meter and timed with a stopwatch. Bronica and Fuji also supply cameras in the 6x7cm format aspect ratio. For an even more user-friendly and flexible medium-format system, you should consider the 6x4.5cm format. There are many systems available, but the Pentax 645AFnII and Mamiya 645 AFD, along with the more expensive Contax 645 AF and Hasselblad H1, are the best cameras in this genre.

You should also consider the 6x6cm format. Manufacturers include Hasselblad, Rollei, Exakta, and Bronica. This square format is probably the favorite for fashion and fine art photography, although Hasselblads are also well represented among photographers who shoot wildlife as well as landscapes. Charlie Waite and Heather Angel have both built superb reputations upon their brilliant use of Hasselblad cameras.

Beyond 6x7cm, Fuji offers one 6x8cm and two 6x9cm models. The Fuji GSW69III is excellent and economical and produces huge transparencies, but it has no metering capability.

Panoramic and large format

If you think that the satisfaction and buzz you get from seeing your first medium-format images is justification enough for the move to this larger format, just wait until you see your first 6x17cm roll film panoramic image—the impact on your lightbox will be stratospheric. When I took this step, and had a gallery print blown up from 6x17cm to 1x3ft on Fuji Crystal Archive paper, I was swept away by the sharpness and intense colors of the image. I was first amazed by this format when I saw Colin Prior's outstanding book on the Scottish wilderness, *Scotland: The Wild Places*. His use of the 6x17cm camera to capture Scotland's wild majesty showed me the true potential of this format. However, it wasn't until visiting a Peter Lik gallery in Port Douglas, Australia, that I realized how good the panoramic format was for intimate natural

left ➤ **Margao, India. This street scene is the opposite of a rural idyll. It is, however, still a landscape. Landscapes that are "busy" work as well as "still" scenes. Handheld Pentax SLR on Velvia.**

facing opposite ➤ **Central Coast NSW, Australia. I came across this enchanting lily pond by chance. While the lilies weren't flowering, it was still an image worth capturing. When I got home, I looked up exactly when they flower, and made a note to return. Ebony RSW + Schneider 80mm lens on Velvia.**

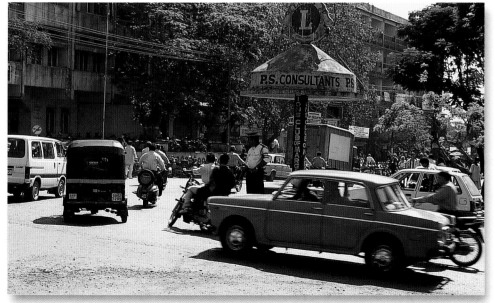

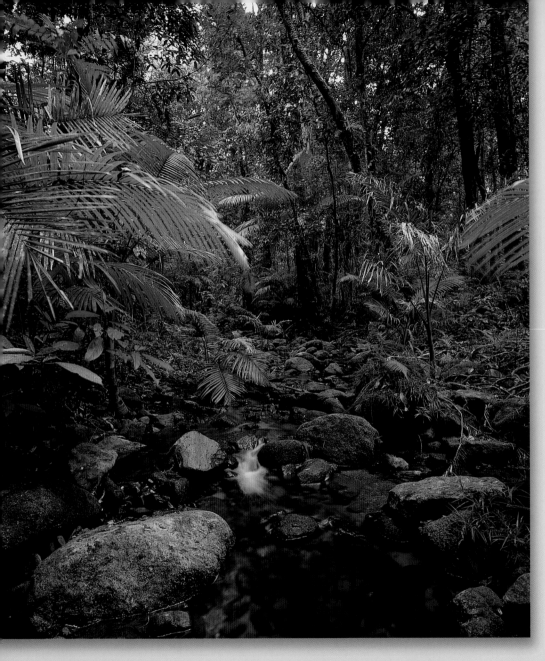

scenes such as inside a rainforest. Peter Lik's beautiful landscapes—and an increased interest by picture libraries in the panoramic format—led me to buy a Fuji GX617 and 90mm lens.

Fuji has become the major name in panoramic photography. Their GX617 body and 90mm, 105mm, 180mm, and 300mm lenses provide a large, popular system, but will cost you several thousands of dollars. It is a good system, but is one that works the photographer hard compared to 35mm or even auto medium-format cameras. Accurate focusing is via an elegant and ingenious ground glass screen placed at the film plane, making exposure quite a time-consuming process. The 90mm lens I favor on the 617 body is an extreme wide-angle equivalent to around 20mm on the 35mm format, and inevitably suffers light fall-off at the edges. To compensate for this, it is necessary to add a center spot neutral density graduated filter (ND grad) that loses a further stop of light as it evens out exposure across the viewing frame.

The only other non-rotating 6x17cm panoramic system camera is the Technorama 617 SIII made by Linhof. Both the Fuji and Linhof use high-quality large-format lenses that have an image circle capable of covering the 6x17cm aspect ratio. This is analogous to masking off a large-format 5x7in view camera to produce a "letterbox" frame of film.

above ➤ **Rainforest Creek, Mossman Gorge section of Daintree National Park, Queensland, Australia. This is one of my favorite pictures, which I sell as a gallery print. Mamiya 711 + 43mm lens.**

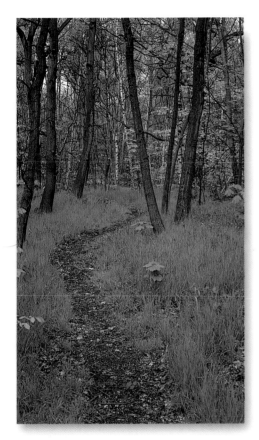

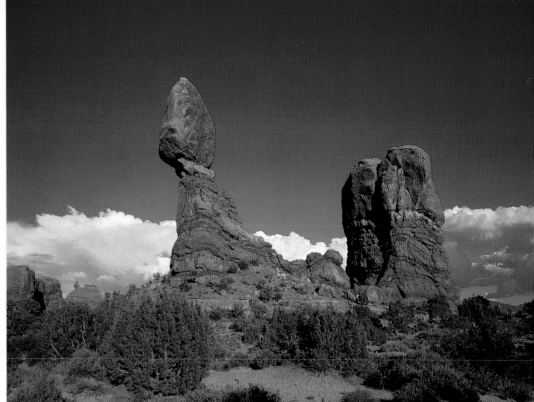

above ➤ **Winding path in an English bluebell wood. This is an example of using a leading line to draw the viewer into the scene. Fuji GA645Zi on Velvia, f/22 at 2sec.**

above right ➤ **Balanced Rock, Arches National Park, Utah, US. It was the strong composition of this image that drew me to take the picture. Fuji GSW69III.**

Smaller panoramic format cameras

Cheaper, smaller panoramic format cameras, such as the Hasselblad Xpan, take the same aspect ratio as 6x17cm, but on 35mm film. This is a rangefinder design that employs both an expensive 30mm lens and more affordable 45 and 90mm lenses. A Tomiyama is available in the 6x24cm format. Tomiyama also makes a very well priced standard 6x17cm model.

360-degree format cameras

Noblex 5x12cm and 5x17cm cameras use a rotating drum to move the lens, exposing the film through a slit on a curved film plane. For the ultimate in panoramic cameras, consider the Seitz Roundshot, which will do a full 360-degree pan image.

View cameras

Many photographers opt for a 6x12cm panoramic format over the 6x17cm one. 6x12cm gives a very pleasing 2:1 ratio, the same as my TV screen. Purpose-built 6x12cm cameras with brilliant wide-angle Rodenstock interchangeable lenses are made by Horseman (SW612 Pro). Linhof also make a fine 6x12cm camera (Technorama 612 PC II). Both of these cameras allow some degree of movement that permits correction of verticals. However, as I alluded to earlier, the most economical way into panoramic photography is via a 6x12cm roll film back that attaches to a 5x4in view camera. These allow roll film economy and pan format on a camera type that permits a wide range of movements, giving extreme depth of field, and

which allows the use of some of the highest-quality optics available today. In particular, 58mm, 47mm, and 35mm lenses by Schneider allow a very wide-angle view of the world on the 6x12cm format. My preferred system for pans is the Fuji GX617 with 90mm lens—it is a landscape photographer's dream.

Since investing in a panoramic camera, my biggest kick is seeing large, high-quality prints from my 6x17cm original Velvia trannies. And it's not just me who feels this way—picture buyers do, too. The area of a 6x17cm transparency is not so different to that of a sheet of 5x4in film. The potential of both is to produce large, truly impressive prints, be they Cibachromes or Fuji Crystal Archive output. This is particularly true when generated by Lightjet 5000, Durst Epsilon, or Chromira printers. A first reason for opting for a 5x4in view camera is that a huge sheet of Velvia film taken with a modern lens design such as the aspherical Schneider lenses will be so sharp and large that it can be printed up to a huge size without losing clarity. The second is that you can control perspective and the plane of sharpness. Thus, large prints retain sharpness because of a large original tranny as well as an extended depth of field via camera movements such as front or rear tilt. These pictures can be so good that when you view them you feel you can almost walk into the landscape.

Using large-format cameras

Rather than being the exclusive domain of the professional—as was once the case—large format is being kept alive by enthusiasts who are after the ultimate quality in pursuit of their art. I get the impression that pros are increasingly moving over to digital capture on 35mm and medium format for the speed and convenience of this newer medium. For those who worry about the state of the art in digital versus film—don't panic. I talk more about digital photography later (see page 31), but for now, let's say that, for landscape photography, the amount of information on a sheet of 5x4in Velvia is way beyond the capability of any digital system that could be used in the field. As long as you need a laptop, wires, batteries and all the bulk of a field camera and its accessories, there is no way that digital is going to usurp film for landscape work.

" ...The pictures make you feel that you can walk into the landscape... "

2A 3 → 3A

Many big-name photographers, such as Jack Dykinga and Michael Fatali, work with large-format photography, and, in the US, photography magazines have always addressed the needs of large-format photographers. Cloaking your head under a black cloth and using what is a slow, bulky system with a plethora of knobs and levers to view the world upside down provides the perfect recipe for a considered approach to image-making.

When you make the move to large format your photography should improve rapidly. The first large-format Velvia transparency that you create on your view camera will justify all the complexity involved. The idea is that since the life-size (i.e. film-size) view you see through the ground glass back of a view camera is reversed and inverted, it actually helps you compose the shot. The image is simplified to a series of lines, shapes, and colors that produce an abstract view of the world. By replacing complex reality with a series of simple graphics, the compositional process is made easy. Many people believe the final picture is inevitably better.

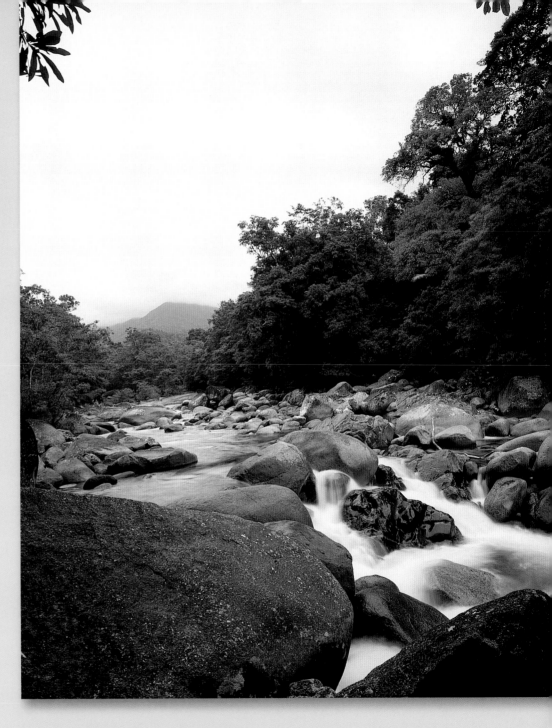

left ➤ **Using the viewfinder on a view camera, which clearly shows how easy—and different—it is to use.**

right ➤ **Mossman River, Mossman Gorge, Daintree National Park, Queensland, Australia. I boulder-hopped to get into the middle of this magnificent river. Mamiya 711 + 43mm lens on Velvia.**

View cameras

The choice of view camera for landscapes comes down to either a metal technical field camera of the types made by Linhof (Master Technica Classic and 2000), Horseman (FA and HD), Toyo (45AII and 45AX) and others such as those made by Wista. Alternatively, a number of manufacturers make wooden field cameras. These include models from Ebony, Wista, Gandolfi, and many others.

Techno junkies are likely to be perturbed by a modern view camera since it remains unaltered from the nineteenth century. It is basically a lens and bellows attached to a box with a glass back. I have two models by Ebony for my fieldwork. My Ebony SV45TE is a legendary folding view camera made for landscape photography. It is a classic camera, superbly crafted. With it you can use 35mm extreme wide-angle to 800mm telephoto lenses via interchangeable bellows and interchangeable film backs (6x12cm, 6x9cm, and 6x7cm). It has a remarkable repertoire of movements, and a rear viewing bellows to negate the dreaded, irritating, and embarrassing black cloth. I also invested in an Ebony RSW, which is a lightweight, frills-free version of its big brother. There are fewer decisions to make regarding setting up the camera, and less likelihood of error. Importantly, it has an international standard back, which takes my Horseman 6x12cm roll film holder for panoramics using a range of lenses. The camera is very much designed for wide-angle lenses, and it will take anything from a 35mm extreme wide-angle to a standard lens of 180mm (longer with a back extender). These lenses and movements are what most landscape photographers use for the majority of their work. It can be easily taken abroad or on long hikes.

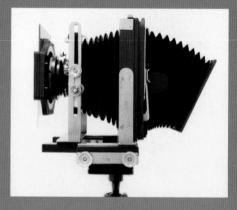

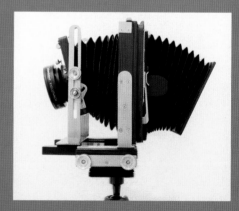

1 ➤ No camera movements.

2 ➤ Front drop avoids perspective problems and helps incorporate more foreground.

3 ➤ Front rise avoids perspective problems associated with converging verticals.

4 ➤ Front tilt brings foreground and distant scenes into focus.

5 ➤ View camera with 'Lee' filter system with ND grad filter attached.

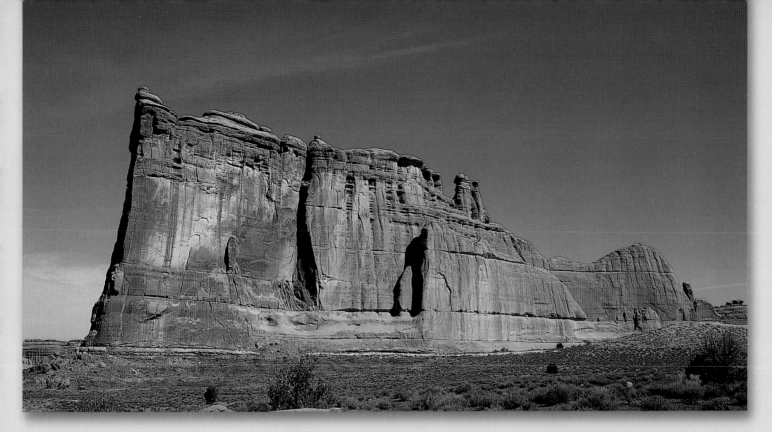

above ➤ **The Organ, Arches National Park, Utah, US. Pentax MZn + 28–70mm zoom on Velvia.**

Front rise and fall

Architectural photographers find facility of front rise and fall crucial, as it avoids the problem of converging verticals on tall buildings. The same facility is also useful to nature photographers, who may wish to shoot a stand of trees, yet keep all the trunks parallel. With an ordinary camera you would angle the camera upward to include the whole scene. However, on a view camera, by placing the camera back parallel to the trees, and employing front rise, you avoid the problem of converging verticals.

Front/rear tilt and swing

Along with rise (and incline bed), fall (and drop bed) and shift are other parallel movements that move the lens up, down, or sideways relative to the center of the ground glass. Front tilt is the most important movement available to the landscape photographer. It helps to achieve a photograph of a rocky foreshore that has both the foaming sea/land interface and distant rocky outcrops in focus. Enhanced depth of field can be obtained if the back is tilted (front and rear tilt can also be combined for even greater effect). Rear tilt will also exaggerate the size and shape of objects such as flowers in the immediate foreground. The same extension of depth of field is given by front and/or rear swing (shift bed), to extend depth for a parallel subject

such as a cliff face, picket fence, or dry stone wall. With medium-format rangefinder equipment, the best I could do for good depth of field with similar subjects was choose an ultra wide-angle lens and select an arbitary point of focus. However, the best with this or any other camera without movements will never match the capabilities of a 5x4in view camera. Like rear tilt, rear swing also alters the shape of objects.

7A 8 ➝ 8A

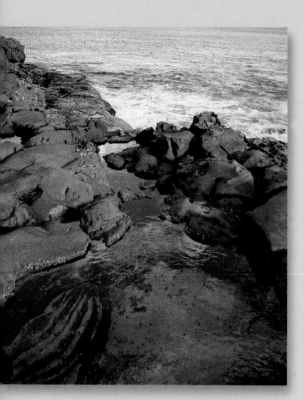

above ➤ **I loved the colors in this rocky shore scene. The winter light in Australia is perfect for landscape photography. Sony Cybershot P72.**

right ➤ **Veiled woman in the grounds of Koutoubia Mosque, Marrakesh, Morocco. Sometimes an image can reflect a place adequately only when it contains a human element to provide "sense of place." Pictures like this blur the interface between landscape and photojournalism. Handheld Pentax SLR .**

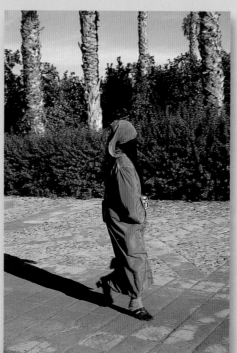

Large-format lenses

Large-format lenses are among the best optics available. I think of any lens with a focal length of below 120mm as wide-angle for landscape work. You should also realize that any lens with an image circle of 161mm will not permit camera movements, since the circle is only just sufficient to cover the film area. An image circle below 161mm is not suited to 5x4in sheet film, but might still be fine for use with a 6x12cm roll film back. Because ultra-wide lenses (75mm focal length or below) exhibit significant light fall-off in the corners, it is prudent to use matched ND concentrically graduated filters to neutralize vignetting. In fact, you can often get away without an ND center spot filter; a little darkening in the corners of a blue sky often enhances an image.

A normal lens for 5x4in landscape work would be a 135mm, 150mm, or 180mm lens. These are cheap and offer excellent image circles for lots of movement. They are much easier to focus on the ground glass than their wide-angle counterparts, since they produce a much brighter and snappier image on which to focus. My standard lens is the 150mm Schneider Apo-Symmar. Telephoto and all manner of specialist lenses are also available for the 5x4in format, ranging from flat field to macro lenses.

Many photographers start off with a 90mm lens on their 5x4in camera. This is roughly equivalent to a 28mm lens in 35mm format, but many landscape pros criticize this focal length as not being quite wide enough. With shots taken with a 90mm lens, I often think that the subject would have benefited more from a slightly wider perspective, perhaps equivalent to one taken on a 75 or 80mm lens. I would recommend you consider the 80mm lens in particular, as the perspective this gives is almost perfect. It is a perfect lightweight partner for the Ebony RSW—weight being a big consideration. In the field you are better off with light but high-performance optics. I went for the aspherical Schneider lenses and subsequently added a fast Rodenstock 75mm wide-angle lens to my kit.

Although a 5x4in outfit is a fussy system to use, cost and weight compare favorably with those of a 35mm or medium-format outfit. In fact, the cost is often less. Because so few exposures are made with large-format lenses, secondhand optics are a real bargain.

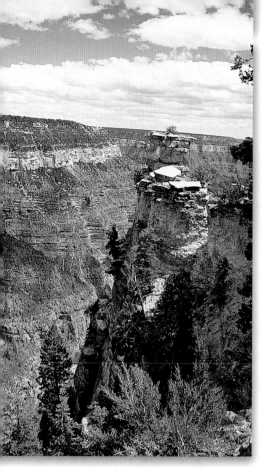

Digital cameras

While this book talks mostly about film cameras for landscape photography, there can be little doubt as to the increasing worldwide popularity of digital imaging as an alternative medium.

What is clear is that digital is here to stay. If and when it does supplant film, it will be 35mm which is the first casualty. Personally, I believe it will never have the quality to replace medium- and large-format Velvia. Good-quality digital backs are available for medium- and large-format cameras, but they are extremely expensive, and will remain so because there will never be the demand for them that exists for smaller chip cameras that are now outselling compact 35mm film cameras. In other words, there are not enough serious photographers around to make it happen in the larger professional formats as it has with the consumer mass-market.

Digital cameras are available with a range of capabilities. At one end you have cameras that can produce little more than a postcard-sized print from a JPEG file, while at the other, you have prosumer fixed-lens compact and professional digital SLR cameras that can easily yield 12x16in (30x40cm) prints that are simply fantastic (with a little help from camera and printer algorithms).

above ➤ **Widforss Trail, Grand Canyon National Park, North Arizona, US. The sentinel-like stack of rock to the right of the frame perfectly counterbalances the canyon walls receding into the distance. Pentax MZ5n with 28–70mm lens on Velvia.**

right ➤ **River Alde in Suffolk, UK. This pleasant scenic image was taken on a 35mm compact. When out walking long distances, such cameras are a godsend. Handheld Pentax 90WR on Velvia.**

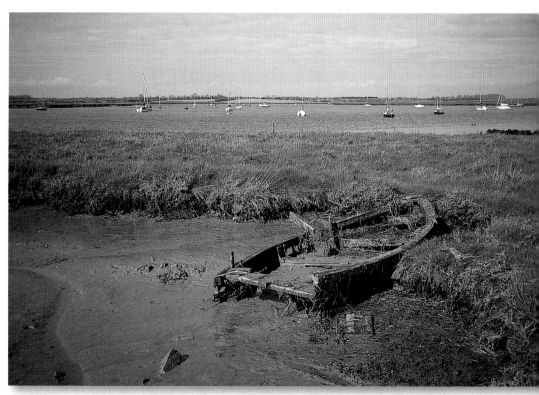

Digital cameras and quality

Digital cameras certainly produce an image of adequate quality for everyday use—the image size having a theoretical limit defined by the amount of data recorded by the CCD or CMOS chip. My Sony Cybershot took great images up to A3 (11¾x16½in) from a 3.2 megapixel file. Cheaper cameras produce images that will stand less enlargement, while more highly specified cameras, such as the 5 megapixel Canon G5 Powershot, can produce images well beyond this size. In time, a digital camera may produce an image with the quality of RAW image data that can be obtained by drum-scanning a 5x4in transparency, and if this ever transpires I will happily say goodbye to film.

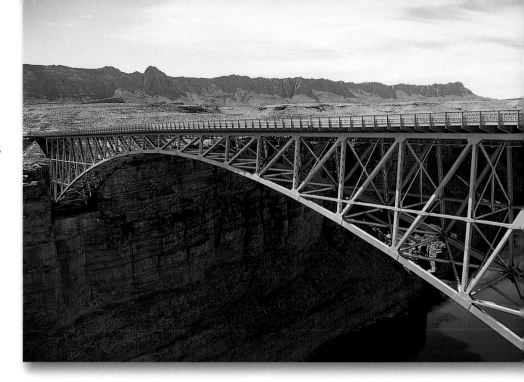

above right ➤ **The Navajo Bridge crossing the Colorado River near Lees Ferry in Arizona, US, symbolizes the taming of the West. Despite the incongruity of the modern bridge in the magnificent landscape, there is a latent harmony between the two. This picture works because it draws viewers' attention across the picture as if they were crossing the bridge themselves. Pentax MZ5n + 28–70mm lens on Velvia, tripod.**

right ➤ **The geometric line-up of these Mediterranean olive trees draws you through the image as a conventional leading line. GA645Zi on Velvia, f/22 at 1/10sec.**

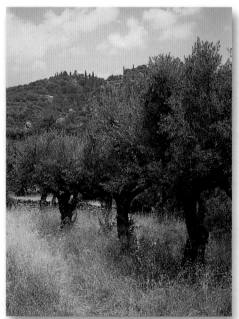

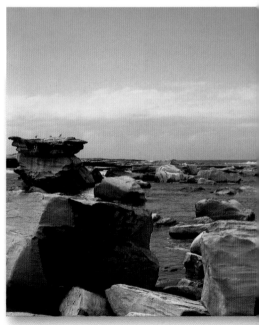

13B

Digital cameras are great fun and, providing you own a reasonably up-to-date computer with a good imaging program such as Adobe Photoshop, are a cheap and effective way to record landscapes. I bought my first digital camera primarily to shoot MPEG movies, but have been amazed at the ability of such cameras to record beautiful stills of scenic locations. If you have no wish to enlarge beyond a reasonable size, the quality of prints is fantastic. There is also the advantage of being able to produce a format that can be instantly emailed all over the world.

Top-of-the-range models produce larger file sizes and better-quality images because they catch and store images in RAW format. These are extremely high-quality files that are not degraded by the camera's digital compression algorithms that kick in when recording an image

as a JPEG file. Despite these advantages, this format is not supported by most image-editing programs. This means you must use your camera's proprietary software to convert them into a more manageable format before use. I always convert them into 16 bits/channel TIFF format before archiving them onto CD. I never take or store serious landscape images as JPEGs, because information would be lost. Instead, I take in RAW format and archive as TIFF files. To give an idea of file size, a 5-megapixel RAW file taken on my Canon G5 Powershot converted into a TIFF yields a 29-megabyte (MB) file. This is the same as a 35mm scan on my Nikon Coolscan III.

Most film purists will want to know how a 29-MB digital file compares to a Velvia transparency. One answer is that the final print size for a Canon G5 Powershot file taken at

maximum resolution is 27x20.25in. This is a good print size, but a 35mm transparency can be scanned to resolutions that exceed this. I have my gallery prints scanned at 300MB resolution, and the print output size possible at this resolution exceeds what I am ever likely to require. However, there is more to print quality than size. The tonal gradations, inherent sharpness, and vibrancy of an original Velvia Quickload 5x4in transparency are not easy to emulate on a chip.

below ➤ **The Skillion, Terrigal, NSW, Australia. I shot this magnificent rocky headland using my Canon G5 digital camera in photostitch mode.**

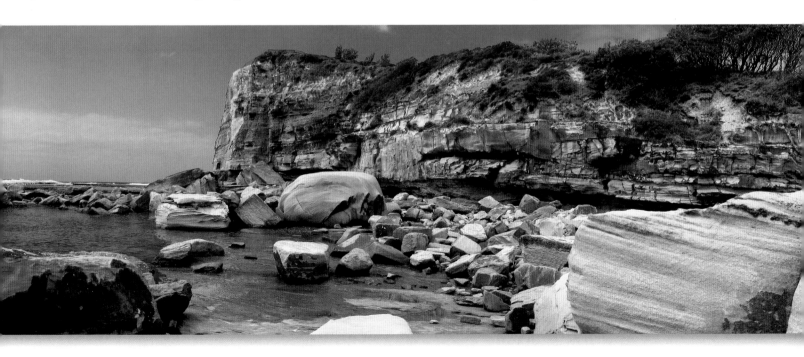

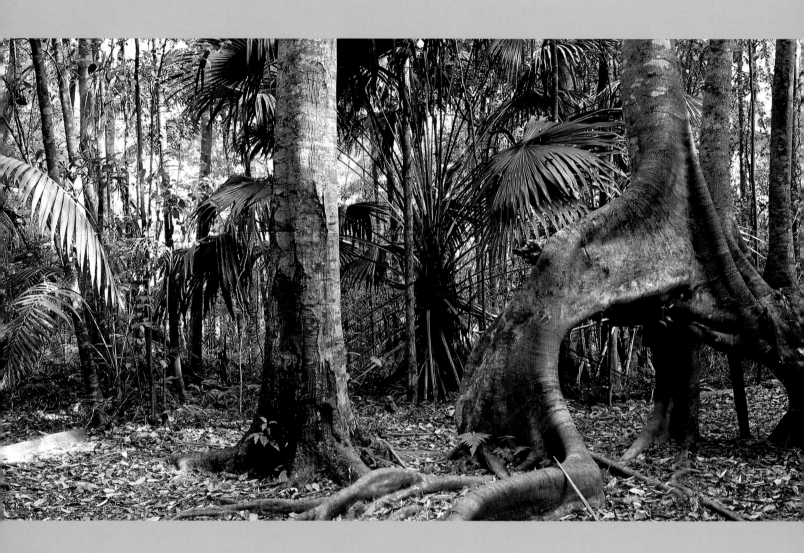

" Photostitching programs enable you to join

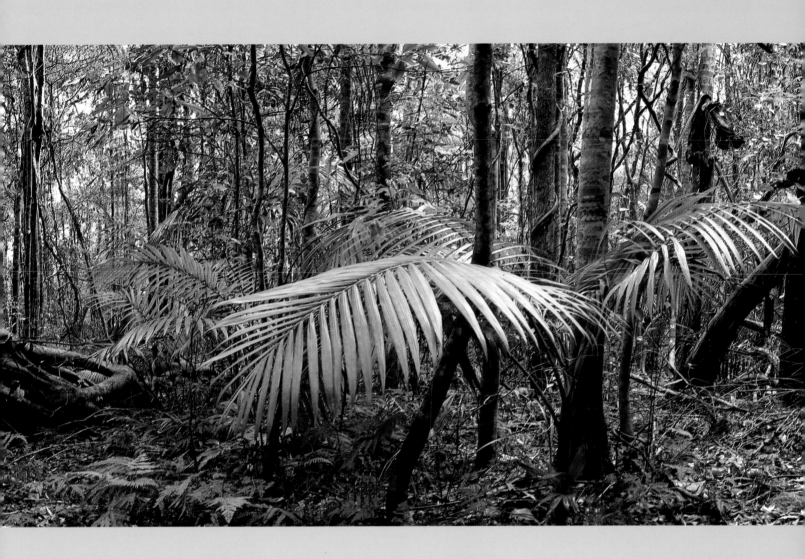

together seamlessly several images at once. „

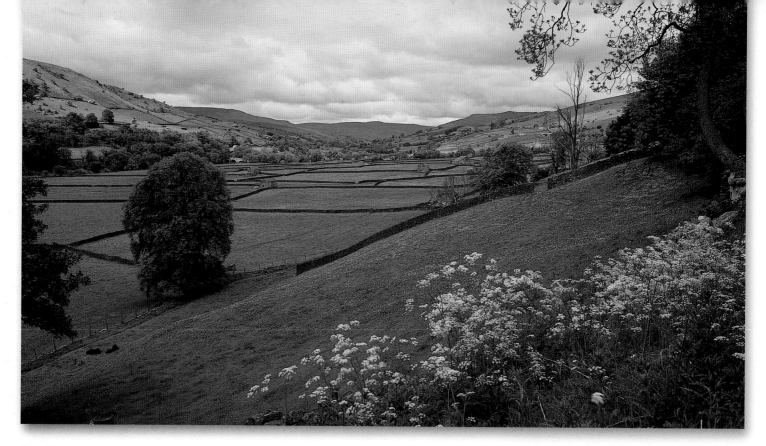

Stitching programs

I recently used a photostitch program to join several images seamlessly together. Each frame represented the maximum file size possible with the Canon G5 Powershot. After stitching the files and doing some cloning and color correction, I had two extreme panoramics that could be printed up to around 30x6in—not far off what I print up to using my Fuji 6x17cm camera. The difference is that the photostitched digital image is limited to a depth of 6in, while a 6x17cm slide can go to any size if scanned appropriately. Although the final quality was high, digital prints do not yet appear to offer the same quality/enlargement coefficient as good-quality medium- and large-format Velvia scans.

above ➤ **Gunnerside, Swaledale, North Yorkshire, UK. The composition is spot on, but the image works only because the season is right. The cow parsley and buttercups in the foreground are transient, but vital to the picture. Fuji GSW69III, Velvia, tripod.**

right ➤ **Tambdi Surla Temple, India, the oldest Hindu temple in the region, makes for a strong composition. Pentax MZ5n + 28mm lens on Kodachrome 64.**

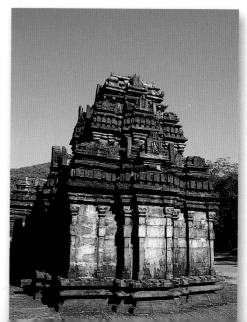

Pros and cons of digital cameras

Advantages

1 Running costs are extremely low as you do not have to buy film.

2 You get instantaneous feedback via the camera's TFT display as to whether a shot has succeeded—you can shoot again if necessary.

3 The medium is instant, with no need to wait for film processing. An image file can be available for an editor minutes after it has been taken, even if he or she lives on the other side of the world.

4 If you buy a digital SLR, you can access all your film SLR lenses.

5 You can easily modify or manipulate images. A small digital camera and light tripod are convenient to take anywhere, yet, via photostitch software, can produce highly original panoramics that have the potential to sell.

6 Digital compacts offer a perfect alternative to 35mm for holiday and family snappers (although serious landscape photographers should think twice before selling their film cameras).

7 You can use the easily produced digital files in PowerPoint presentations, word processor documents, and desktop publishing programs.

8 Digital cameras make great lightweight proofing tools for subsequent shoots involving a lot of equipment and long hikes.

9 Because chip sizes are smaller than 35mm film, lenses designed for 35mm SLRs increase their nominal focal length on a digital SLR. This is an advantage if you have a passion for telephoto shots, but a disadvantage if you like taking wide-angle perspectives.

10 Manufacturers are now coming up with super-wide lenses that will allow normal wide-angle shots on digital SLRs, and super-wide shots on traditional film SLRs.

Disadvantages

1 Set-up costs are high—you need a good PC or Mac and archiving ability.

2 Files tend to be RGB format (most publishers prefer CMYK).

3 The ease with which images are achieved can lead to a less considered approach to image-making.

4 You can spend a lot of time downloading and tweaking images in Photoshop. To get the most from a digital camera you have to do some manipulation, since image color cast seldom reflects the original scene. I find it more satisfying, and easier, to view transparencies on a lightbox than I do digital files on a PC.

5 There is no "wow" factor with a digital file on screen. There is a "wow" factor with a vibrant medium- or large-format Velvia transparency viewed on a lightbox.

6 In landscape photography, quality is everything—the image needs to retain detail, tonal range, and vibrancy.

7 You have to be super-organized to ensure that you file your image files correctly, otherwise the one you are looking for is difficult to find.

8 Digital cameras rely heavily on battery power.

9 Pro backs for medium- and large-format are extremely expensive, and are likely to remain so. They also require significant computing power, often with a laptop hooked up to the camera.

10 I can shoot a roll of Velvia on any 35mm camera, new or secondhand. With digital cameras, a blend of technological compatibility is required and as PC software evolves, requiring faster processing power, so hardware must evolve in parallel. You can't predict how compatible your storage media of today will be with tomorrow's needs.

right ➤ **English bluebell wood. For complex scenes with detail, opt for a wide-angle lens. Mamiya 7II + 43mm lens equivalent to 21mm on 35mm format.**

far right ➤ **Millaa Millaa Waterfall, Atherton Tablelands, Queensland, Australia, summing up all the romance of tropical forests. Mamiya 7II + 43mm lens on Velvia.**

below ➤ **Red Rock formations, Capitol Reef National Park, Utah, US. Pentax MZ5n + short zoom lens and 81B warm-up filter on Velvia.**

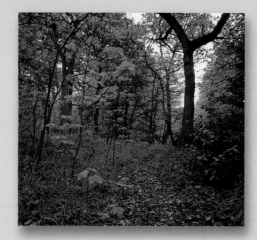

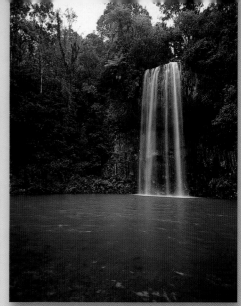

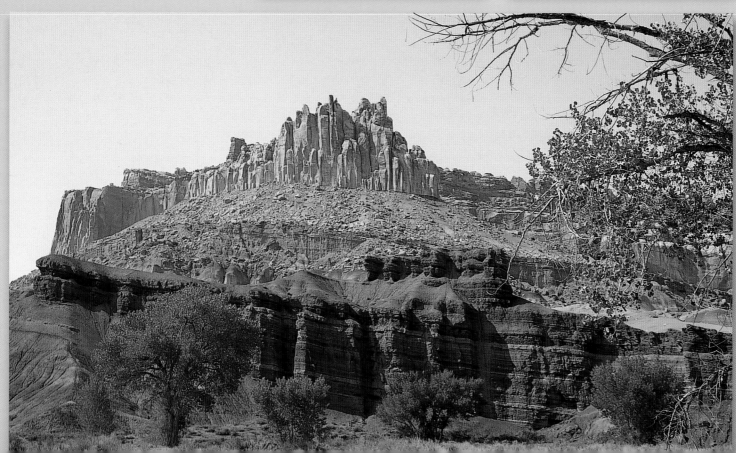

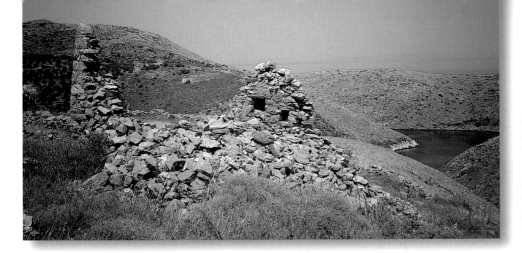

left ➤ **Ruined building near the temple of Poseidon, Inner Mani, Greece. GA645Zi on Velvia, f/22 at 1/20sec.**

below ➤ **The Colorado River in the US cuts through desert, providing a fantastic leading line towards the distant mountainscape. Pentax MZ5n + 28–70mm lens on Velvia.**

Using image-manipulation software

If you want to learn about digital photography and image manipulation, you must become familiar with photo-editing software. Professionals tend to use Adobe Photoshop.

It is a learning curve to get to grips fully with this amazing software, but you only really need to know key aspects. Here are some of the more useful aspects for landscape photographers.

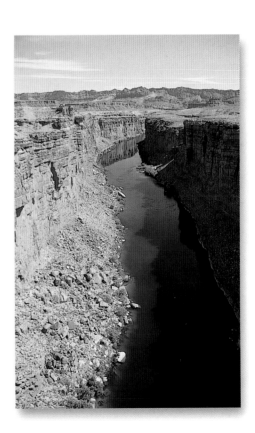

Things to consider

● I always work with the biggest file size possible to retain native detail in the final print. All my files are saved as a TIFF (Tagged Image Format File).

● The first thing I do to any image is to crop it to the most aesthetically pleasing composition. Look for the Crop tool in the Photoshop tool bar.

● Sharpen your image (but don't overdo it). Use around 100 percent sharpening. Go to Filter>Sharpen>Unsharp Mask and enter your value. This approach won't improve a hopelessly soft or out-of-focus image.

● Give your image a bit of punch by boosting the colors. Go to Image>Adjust>Hue/Saturation. You can add a bit more saturation (seldom beyond 30 percent). I try to recreate the level of color I saw through the camera viewfinder at the time of exposure.

● I also sometimes find it necessary to adjust levels (Image>Adjust>Levels) and to pull a slight S curve to add punch (Image>Adjust>Curves).

These effects don't really alter the image—they simply "enhance" it, and sometimes overt manipulation is required. The best tool for this is the Cloning tool. Using this you can get rid of unwanted elements such as that annoying footprint you didn't see at the time. Care is required as you clone surrounding pixels into the offending area of the image.

I believe that film and digital are parallel technologies that are not mutually exclusive, and that both will be around for many years to come. In some ways, digital is the most exciting, since the potential is unknown. I look forward to seeing where it leads us.

Exposure meters

If you have made the decision to go big with your imaging—that is, to use 6x12cm, 6x17cm, or 5x4in—you will have to forego auto-everything photography. In particular, no cameras in these formats come with autoexposure control—the most obvious implication is that you need to buy and use an exposure meter.

I use the Sekonic L-508 zoom master exposure meter, which gives me incident and spot-reflected ambient metering. With panoramic or sheet film, the cost of each exposure increases significantly compared to the smaller formats. This makes consistently accurate measurements important, particularly for exposing transparency film, which has little latitude for error.

below left ➤ **Chiricahua Mountains, which straddle the Arizona/Mexico border. Geronimo must have had a great time living amongst these amazing rocks. The rheolytic formations provide interest that extends from foreground to distance. Mamiya 7II + 65mm lens on Velvia, tripod.**

below ➤ **Tower house on cliff edge in the Mani, Peloponnese, Greece. This was taken late in the day in low, warm, directional light. The cypresses add to the mellow feeling. GA645Zi on Velvia, f/22 at $^1/_{10}$sec.**

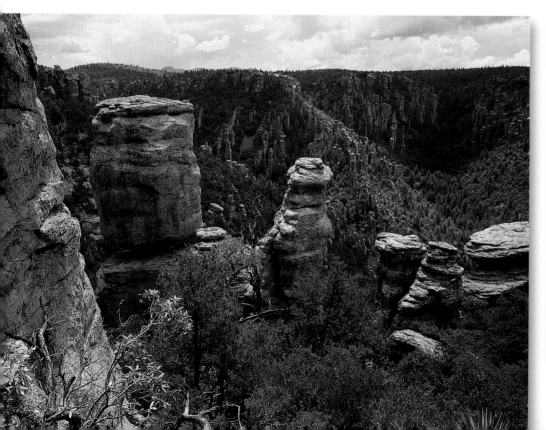

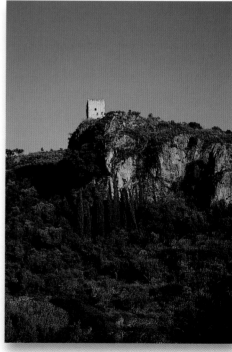

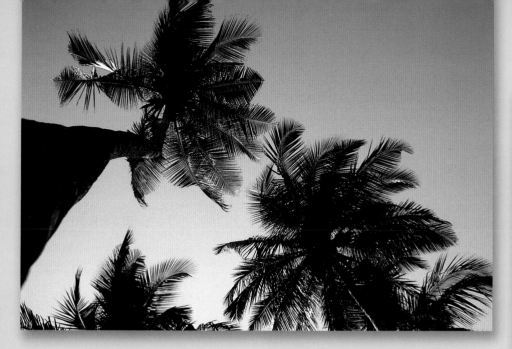

Until I began taking larger-format images, I used incident light measurements to record light falling on the subject via a lumisphere dome. This is considered to be the most accurate way of exposing as the color and reflectivity of the subject do not unduly influence exposure value. I now use a reflected spot meter. This reads the intensity of light reflected from the subject, which biases the meter depending on tone, color, and contrast, because all meters "see" their subject as an 18 percent neutral gray. In landscape photography, metering distant objects over a wide area of view, with highly reflective surfaces and extreme contrast—including backlit situations—a reflected spot reading can be very useful. My zoom spot meter can average two or three exposure readings from critical highlight and shadow areas, providing suggested optima for the overall scene.

Most texts advise you to use an 18 percent neutral graycard placed in front of the subject to avoid aberrant readings. I use a graycard for situations that are hard to evaluate, but generally I use a very narrow angle of view on my Sekonic meter to target any green foliage, and use the reading given. With practice, you will recognize targets that are the equivalent of 18 percent gray. I prefer green vegetation, but rocks are good too, if not too bright or very dark. Some people still prefer a hand-held incident meter reading to relying on their medium-format camera's reflected meter reading. Down to 4sec, I rely on my Mamiya 7II's automatic exposure system. 35mm SLR cameras are now very dependable, even in the trickiest lighting.

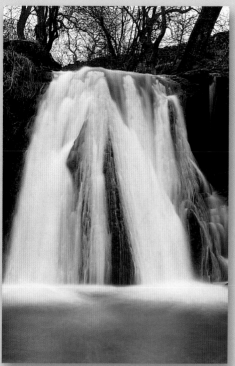

above ➤ **Janet's Foss is a pretty waterfall near Malham in North Yorkshire, UK. I had to overexpose by two stops to compensate for the white water and reciprocity due to the low winter light. Pentax MZ-5 + 28–70mm lens on Velvia, 4sec at f/16, tripod.**

above left ➤ **Coconut palms. Perspective can alter the impact of a picture. By shooting upward with a wide-angle lens, I have altered the conventional idea of what a tree should look like. Handheld Pentax SLR on Velvia.**

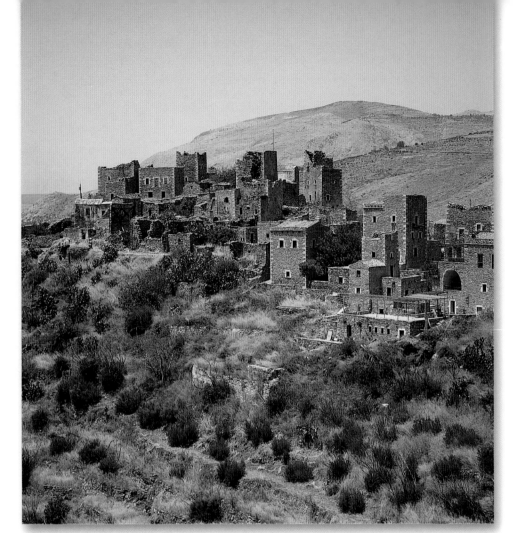

left ➤ **Vathia, Inner Mani, Peloponnese, Greece. This ancient hill town—once full of warring clans—now makes for a beautiful scenic image. GA645Zi on Velvia, f/32 at 7sec.**

Tripods

The secret to sharp pictures is to use a tripod. For large-format and panoramic camera users, a tripod is essential. The ideal tripod is really too heavy to carry, so you need to compromise. Look for a tripod with heavy-duty construction that will also allow low-level work, preferably without the fuss of reversing the center column and attaching the camera from below—clearly not practical with a wooden 5x4in view camera. I wouldn't consider a tripod without sealed legs so that it can be set up in water, sand, or mud. Buy a strap to carry your tripod over your shoulder for long hikes. The camera should attach to the tripod by a quick-release plate that forms an integral part of a large ball-and-socket head.

I use the Benbo Mark I and Unilock Model 1600 tripods. They extend to about 5ft (1.5m), and the three legs are connected by a bent bolt. Along with the center column, the legs can be locked into place by twisting a single lever. This means the legs move independent of one another and can be placed in any position, on any terrain.

Tripods are now being made of carbon fiber, which provide a strong, lightweight construction, ideal for hiking around mountainous terrain. Gitzo and Manfrotto make excellent carbon fiber tripods. Unfortunately, there is a price to pay—between two and three times that of conventional alloy tripods.

Gadget bags

There is a lot of hype around about camera bags. Some of them are frankly little more than a fashion accessory, but well-chosen bags do actually protect your kit, and at the same time they can offer a pragmatic solution to both transporting and accessing your various photographic bits and pieces when you need them. I love the LowePro range, which comes in various different sizes enabling me to tailor what I take to a shoot, depending on what I think my requirements will be. It is certainly worth investing in a heavy-duty protective bag for traveling. But another type of bag I frequently use, particularly when out in a wet environment, or with my macro set-up, is a plastic shopping bag. I buy three or four before going abroad. They provide instant access to my macro set-up, which wouldn't fit any gadget bag, and are completely dust- and damp-proof.

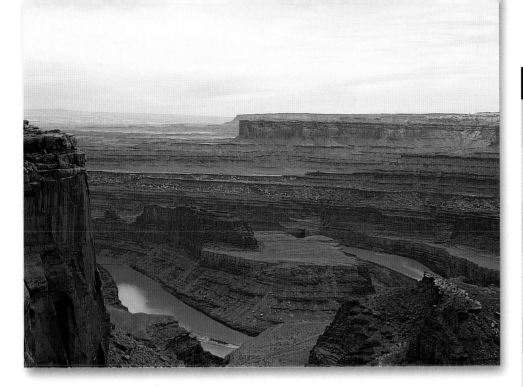

above ➤ **Dead Horse State Park, Utah, US.
This picture is not as good as it might be,
as I ran out of Velvia and was forced to use
another brand. The resulting image is much
less vibrant. 35mm format + 28mm lens.**

left ➤ **English woodland. When I shoot images
in woodland, I try to orchestrate the various
elements in a scene harmoniously. I consider
a picture has failed if it contains incongruity
or is too chaotic. This one blends the visual
elements in a complex scene very well.
GA645Wi on Velvia, f/13 at 11sec.**

Useful extras

- **Stopwatch:** essential for long exposures in dim light.

- **Kodak graycard:** for correct exposures in tricky light situations.

- **Swiss army knife:** many uses, including to attach the tripod quick-release plate.

- **Garbage bags:** to lay out equipment on damp ground and protect cameras from the elements.

- **Torch:** for early and late shoots.

- **Spare batteries:** for camera, handheld meter, and torch for dawn and dusk work.

- **Spare cable release:** these things are always falling to bits.

- **Can of compressed air/blower brush:** for removing grains of sand or dust from delicate mechanisms.

- **Internet access:** the Web is brilliant for getting up-to-date weather reports.

- **Handkerchief/microfiber cloth:** useful for drops of rain on your lens.

- **Pencil and notebook:** to record date, location, exposure, time, and ideas.

- **Compass:** useful to predict where the sun is going to set or rise.

Film

Until the introduction of Fujichrome Velvia, I used Kodachrome color reversal film. Today, I still use Kodachrome 64 for 35mm work, particularly for close-ups of nature. Kodachrome 64 and 25 were reputed to have extremely long archival qualities and the sharpness of both emulsions is exceptional. However, with fine-grained Velvia came a vivid saturation of colors and sharpness that is a revelation to landscape photographers.

Transparency versus print film

If you plan to market your images, you should use color transparency film. Color transparencies are the preferred medium for color pictures in magazines, calendars, and books. They are also perfect for guaranteeing quality from framed gallery prints. They have many advantages over prints—they are sharp, and come back exposed as intended (color printing machines automatically compensate/adjust print exposure); they are cheaper and are easier to store in filing systems.

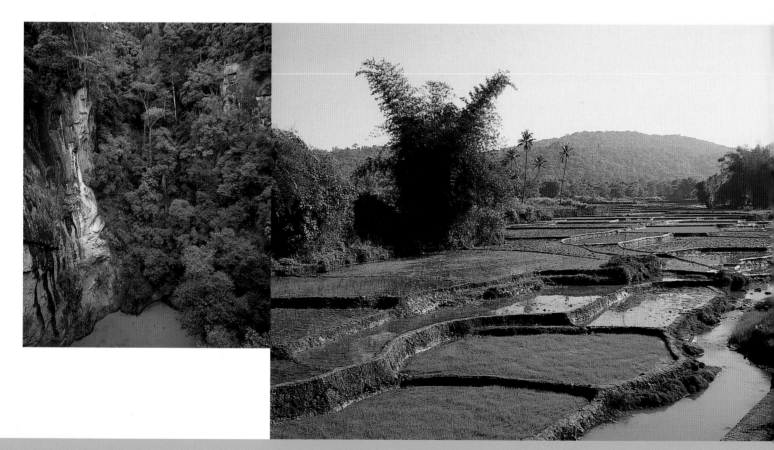

❝ Tripods are now strong and lightweight

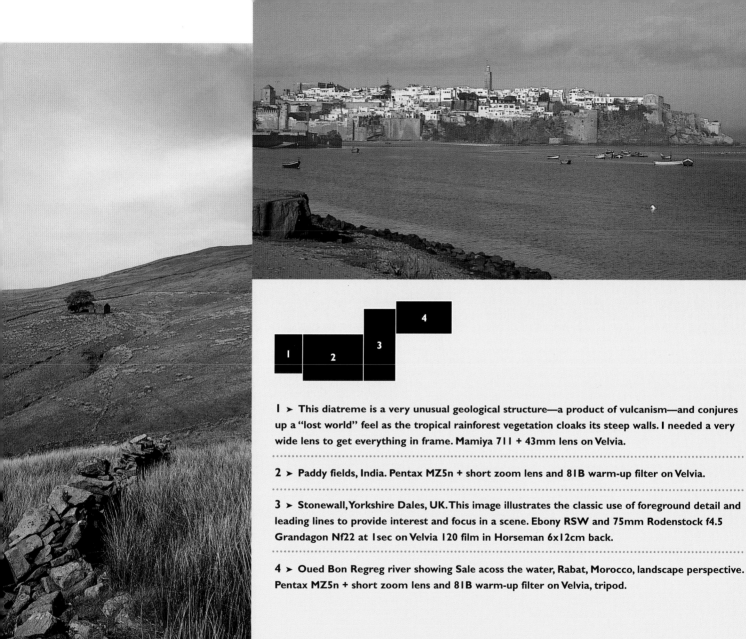

1 ➤ This diatreme is a very unusual geological structure—a product of vulcanism—and conjures up a "lost world" feel as the tropical rainforest vegetation cloaks its steep walls. I needed a very wide lens to get everything in frame. Mamiya 711 + 43mm lens on Velvia.

2 ➤ Paddy fields, India. Pentax MZ5n + short zoom lens and 81B warm-up filter on Velvia.

3 ➤ Stonewall, Yorkshire Dales, UK. This image illustrates the classic use of foreground detail and leading lines to provide interest and focus in a scene. Ebony RSW and 75mm Rodenstock f4.5 Grandagon Nf22 at 1sec on Velvia 120 film in Horseman 6x12cm back.

4 ➤ Oued Bon Regreg river showing Sale acoss the water, Rabat, Morocco, landscape perspective. Pentax MZ5n + short zoom lens and 81B warm-up filter on Velvia, tripod.

which is ideal for hiking around mountainous terrain. **"**

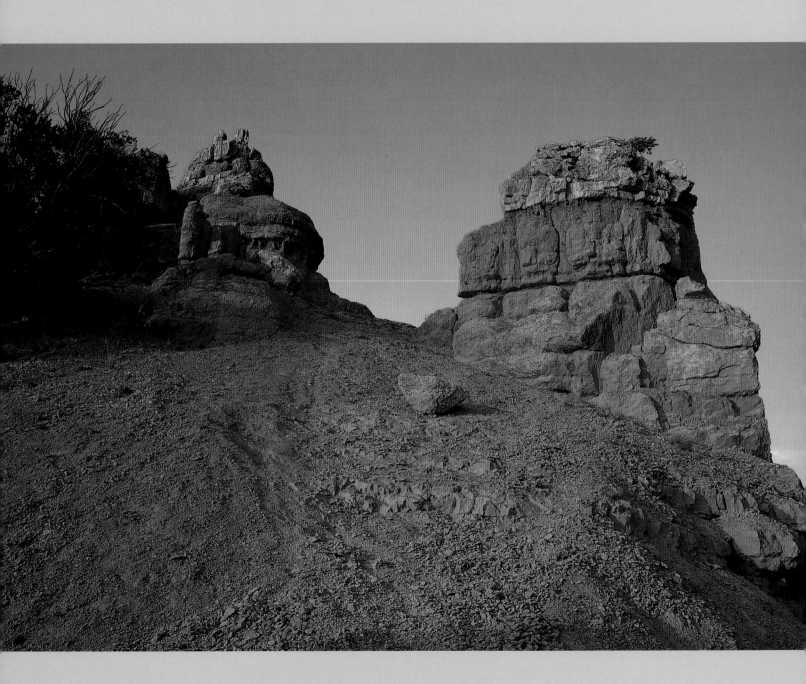

Which brand?

Selecting a film brand is pretty subjective. You will need to select the slowest film speed that suits your prospective image. A slow film such as Kodachrome 64 or ISO 50 Velvia is virtually grain-free, but, as ISO number increases, a compromise occurs between speed, grain, and (therefore) sharpness. At ISO 400 and above your ability to produce bitingly sharp images reduces, and I would suggest that unless you are specifically after a grainy effect a fast film would simply compromise a quality optic. Besides, grain effects can easily be produced in Adobe Photoshop.

As I've mentioned, my favorite film is Velvia. Fuji has an alternative in Provia 100F, which has a finer grain structure, but is, paradoxically, a stop faster. I sometimes use this, as not only does it offer an extra stop that is useful for low-light, but also it is not as sensitive to reciprocity

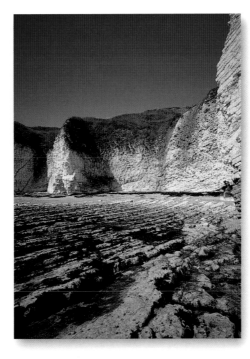

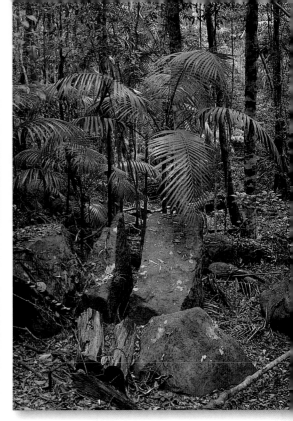

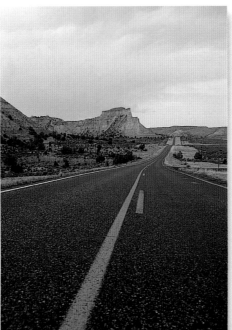

left ➤ **Bryce Canyon, Utah, US is a beautiful national park. You approach through Red Canyon, which lights up a vivid red as the sun sets, and is even more colorful than Bryce. Mamiya 711 + 65mm lens on Velvia.**

top right ➤ **Flanborough, UK. This 5x4in image of the sea cliffs and rocky foreshore required no front tilt with the cliffs at right of frame, which would pierce any altered plane of focus. I metered off some seaweed as the graycard angle was too difficult to position optimally in the highly directional sun. To achieve the best depth of field, I stopped down to f/32, shooting on Velvia Quickload.**

above ➤ **Sub-tropical rainforest, Katandra Reserve, NSW, Australia. There is little point shooting woodland on a bright day, as the contrast would spoil the scene due to the limited latitude of slide film—and Velvia in particular. Cloudy, overcast days are best. Fuji GA645Zi on Velvia, manual exposure, bracketing toward longer exposure to compensate for reciprocity failure.**

left ➤ **Scenic Highway 12, Utah, US. For impact, use a wide-angle lens, get low, and include a road tapering off into distant scenery. This is a classic use of leading lines. Pentax MZ5n + 28mm lens on Velvia.**

failure as Velvia. This means exposures remain spot on down to several seconds. Despite this advantage, Provia 100F does not have the same vibrancy and impact. You should experiment with different brands and make up your own mind; if you like it, stick with it, and learn to judge how it behaves under different conditions.

To a certain extent, the same is true of 120 (and 220) roll film. You can buy an individual 35mm or roll film for a few dollars, but sheet film costs around the same amount per sheet. Getting in even the smallest unit of pre-loaded sheet film is expensive, so you need to know that a brand is right for you.

Today, my choice of film is invariably the same. I have settled on Velvia, Kodachrome 64, and Provia 100F for 35mm use. For 120 roll film (including 6x12cm and 6x17cm panoramics) I use mostly Velvia. For 5x4in sheet film I opt for Velvia Quickload. However, when the Kodak Readyload system becomes widely available, I will use Ektachrome E100VS. These "chromes" all respond in unique ways to light. The color palette they offer therefore varies—what suits my taste may not suit yours. (See the table on page 68 for comparisons between films, the recommended filtrations, and exposure compensations required for long exposures.)

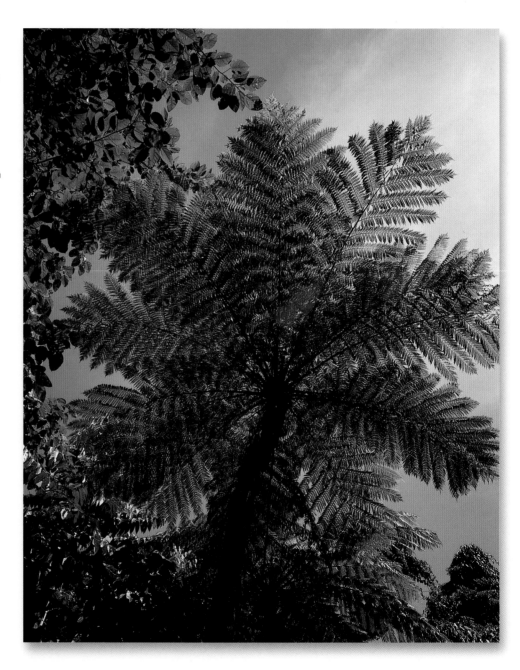

right ➤ **To isolate this tree fern, I fitted a wide-angle lens and pointed upward.**

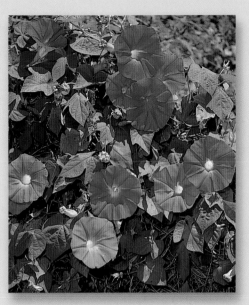

far left ➤ **The 6x17cm format also works well with a few subjects when used in a vertical orientation, as with this shot showing a rural landscape. On balance, however, 6x12cm is a preferable aspect ratio for vertical panoramics. Fuji GX617 + 90mm lens on Velvia.**

left ➤ **Convolvulus flowers. Going in close can be used to isolate elements from their backdrop. GA645Zi on Velvia, f/11 at 1/90sec.**

below ➤ **Fishing boat at dusk, Arabian Sea. Pentax MZ5n + short zoom lens and 81B warm-up filter on Velvia.**

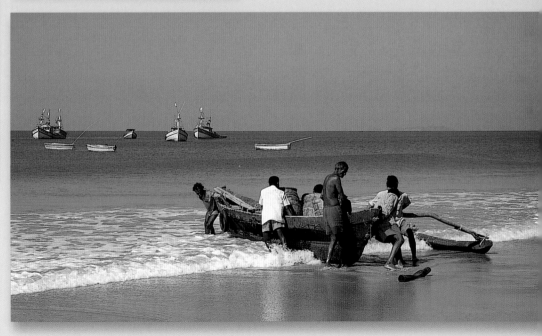

9B 10 ➤ 10A

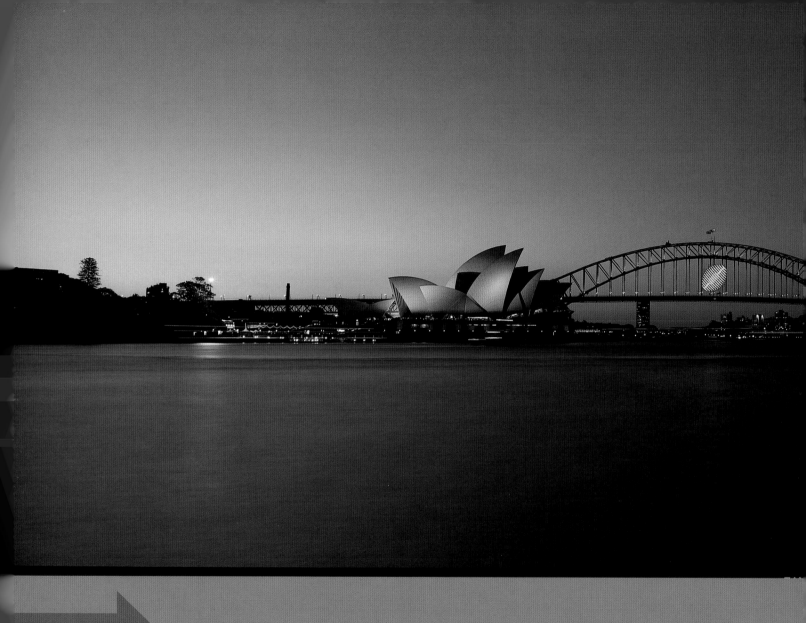

It's all about light

"...light is the defining factor in a landscape..."

Seeing the light

As your passion for landscape photography grows, you will soon realize that light is the defining factor in a landscape. You become attuned to the seasonal variation in light, most particularly in temperate latitudes where day length alters so much over the year. Photographers see each individual day as a changing canvas determined by the sun's position and the mood of the weather.

The ends of the day

The good thing about winter in temperate latitudes is that dawn comes late, while dusk arrives early. If, like me, you don't relish rising at 3am to catch a potentially interesting sunrise, winter will undoubtedly be the best time to catch these dramatic moments of fiery light. Late in the day, I make use of my compass to predict where the sun is going to set, and try to scout for plants or trees that would make good silhouettes against an electric sunset.

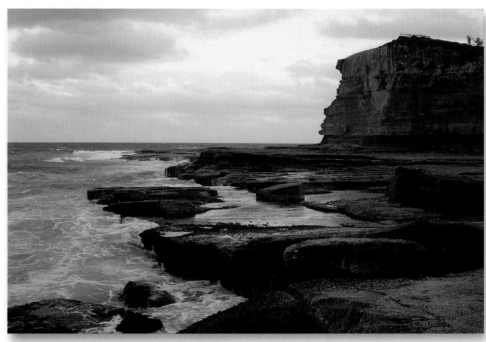

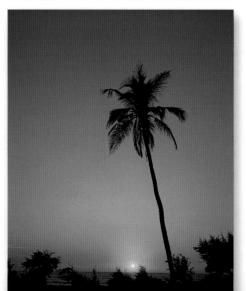

above ➤ **The Skillion, Terrigal, NSW, Australia. This Sony Cybershot P72 image shows that good landscapes are possible at 3.2 megapixels.**

far left ➤ **I wanted something vivid and graphic from this silhouette. Mamiya 7II + 65mm lens on Velvia, tripod.**

left ➤ **Goa, India. Fuji GA645Wi on Velvia.**

right ➤ **The Grand Canyon, North Arizona, US, captured on a large 6x9cm format, without filters. Fuji GSW69III on Velvia, f/5.6 at 1sec, tripod.**

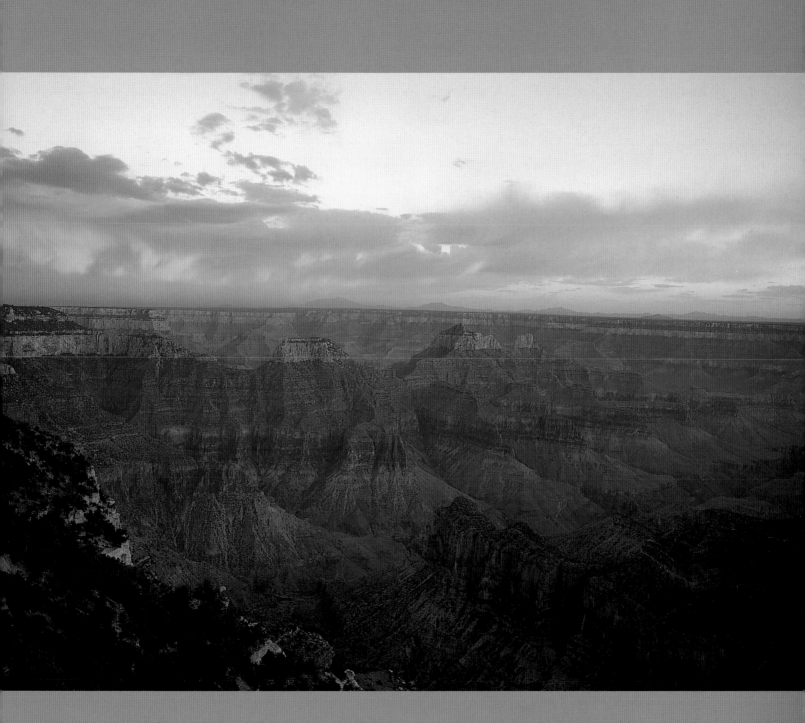

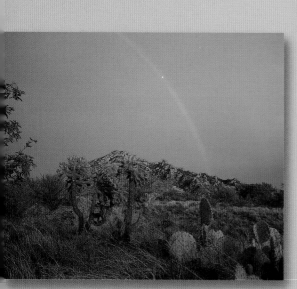

The golden window of opportunity lasts only a short time, so you need to be in position well in advance. Pre-planning pays dividends.

With an auto-everything camera, you can shoot dawn and sunset views using the camera's elected exposure value (EV), bracketing up to 1½ stops to ensure success. The economy of 35mm makes this simple, but with much less economical 5x4in sheet film, the cost of the medium precludes too much bracketing. Experience will help you save on film, but you will always need to do some bracketing.

above ➤ **These cacti were shot near Kitts Peak, Arizona, US, as the sun was setting. Mamiya 7II + 65mm lens on Velvia, tripod.**

right ➤ **A narrow street in Monemvasia, Laconia, Greece. GA645Zi on Velvia, f/27 at 7sec.**

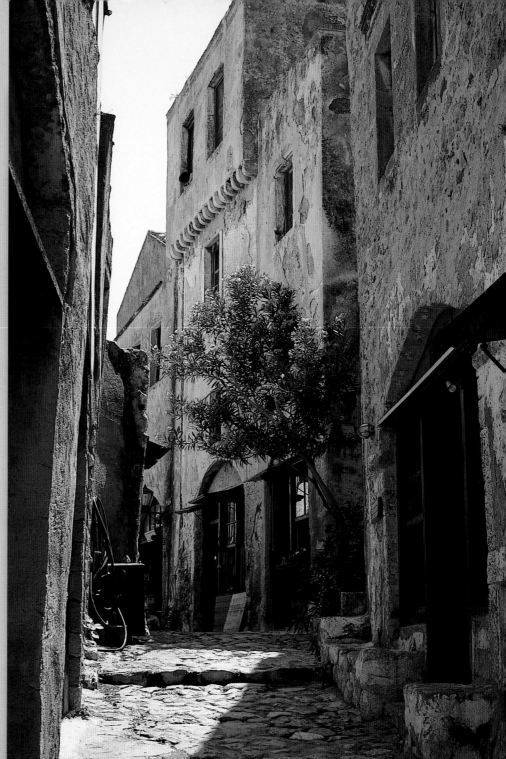

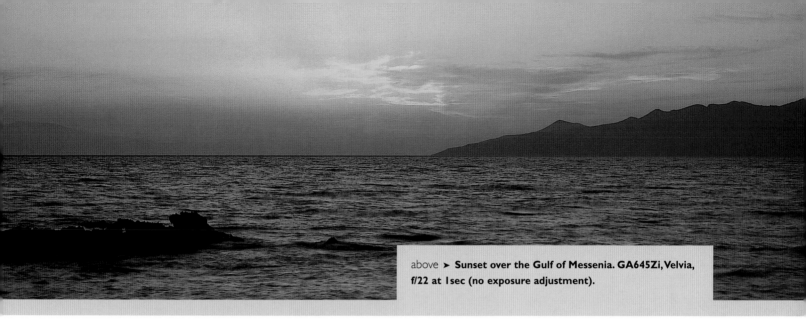

above ➤ **Sunset over the Gulf of Messenia. GA645Zi, Velvia, f/22 at 1sec (no exposure adjustment).**

" ...the problem with sunsets is the high contrast... "

The problem with sunsets is the high contrast. You may opt to tone down the sky with an ND grad filter, and meter for the foreground, or you could spot meter from a floodlit building that approximates to 18 percent gray, or an area of colored sky away from the sun. This should be around 1 to ½ stops brighter than neutral gray.

Auto-everything cameras often render a sunset darker because of underexposure caused by the meter being fooled—easily done if the sun is low and lined up with the lens axis. This can be beneficial, deepening red and orange and losing superficial detail to shadow. It can also augment silhouettes of iconic subjects.

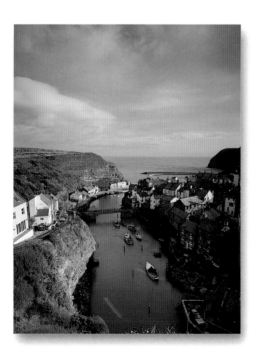

above ➤ **Cholla cactus near Kitts Peak, Arizona. Mamiya 7II + 65mm lens on Provia.**

left ➤ **Staithes, North Yorkshire, UK. Ebony SV45TE + aspheric 80mm Schneider Super-Symmar XL, f/22½ at 1sec on Velvia Quick Load.**

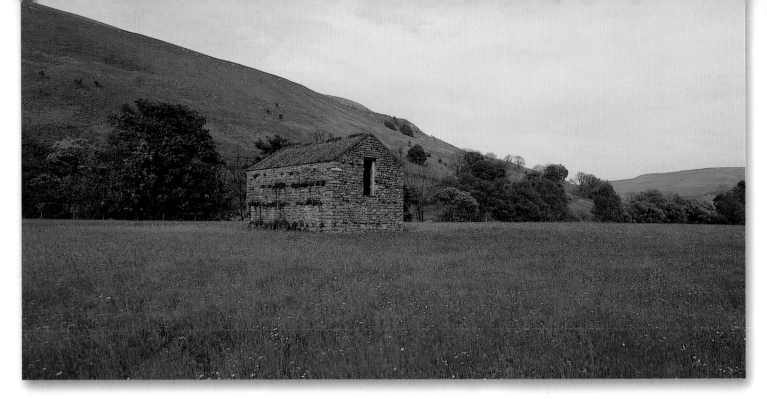

High- and low-contrast scenes

Finding good light is a major determinant in the success of your photographic endeavors. Try to avoid high-contrast situations. The eye can adjust to a remarkably steep gradient in brightness—as great as 400:1. Unfortunately, film cannot handle such a gradient and shadow detail or highlights—or both—are sacrificed. The only solution is to take spot meter readings from the various zones of illumination, and gauge the optimum exposure for the scene. Film has exposure latitude of around +/- 2½ stops, although at these extremes you are not going to record much detail. One way to tackle a high-contrast scene is to meter an area of grass or spring foliage, or better still an 18 percent reflectance graycard placed away from direct sunlight. You can then spot meter areas of shadow and highlights within your scene, and see how many stops away from

above ➤ **Stone barn, Muker, Yorkshire Dales, UK. This photogenic barn was taken on a May evening when the contrast had dropped and the light was softer. Ebony RSW + 75mm Rodenstock, f/4.5 Grandagon N, front tilt on Velvia 120 film in Horseman 6x12cm back.**

right ➤ **The rule of thirds is an interesting dogma. Immediately after taking an earlier picture of this scene, I rearranged the set-up to follow the rule of thirds, placing the pole in the left third of the frame. I didn't think that the composition worked so well. However, the clouds were shaping up, so I used a 0.9 ND grad to add some menace. Ebony RSW + 75mm Rodenstock lens, f/22½ at 1sec.**

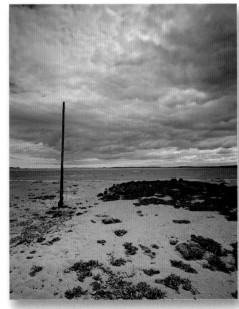

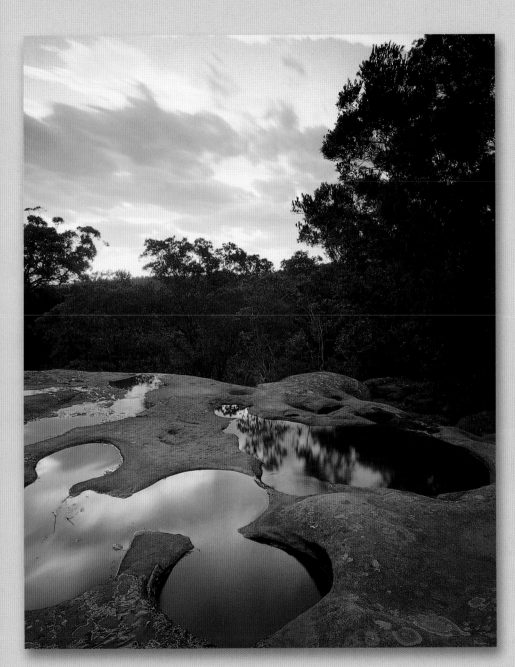

left ➤ **Above Somersby Falls, NSW, Australia, at sunset. These Falls are in Hawksbury Sandstone country and are pitted with erosion holes that retain water even when the weather gets dry. I tried to use these pools of standing water above the falls as foreground interest, while the distant sunset over the wild scenery of Brisbane Water National Park provides an additional focus of interest. Ebony RSW and Rodenstock 75mm lens on Velvia 5x4 Quick Load sheet film. F16.5 at 4 sec, with a hard interface 0.6 ND graduated filter and an 81D warm up filter. I used front axial tilt to link focus on near and far elements.**

"ideal" they are. With low-contrast lighting, most scenes are free of extremes in illumination and it's easy to get spot-on exposures. Indeed, I wouldn't bother to bracket my exposures. In landscape photography, my greatest subject is intimate landscapes. Experience has taught me how to get the most from them. If at all possible, I will only ever shoot under cloud cover, using soft, diffused light. I don't bother with a graycard, as a number of natural features invariably provide the perfect neutral gray.

Common "neutral gray" features

- **Classic red brick buildings**

- **Spring leaves**

- **Grass**

- **Late spring and high summer dark green leaves:** up to +1 EV

- **White clouds:** up to +1½ EV

- **Dark storm clouds**

- **Cloudless blue sky at or near the horizon** (away from the sun)

- **Snowscape:** up to +1½ EV

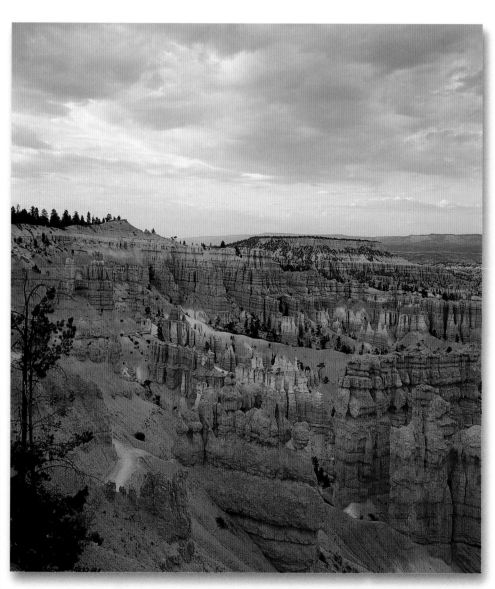

above ➤ I believe that Bryce Canyon, in Utah, is the world's most photogenic location. I love shooting the sunset over the canyon. I spent almost a week here and that wasn't long enough. **Mamiya 7II + 65mm lens on Velvia, tripod.**

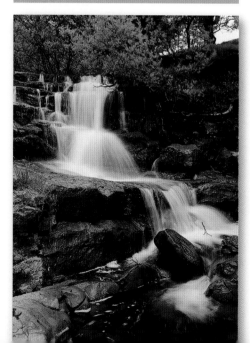

left ➤ **East Gill Force, UK, captured as an intimate landscape. Fuji GSW69III on Velvia.**

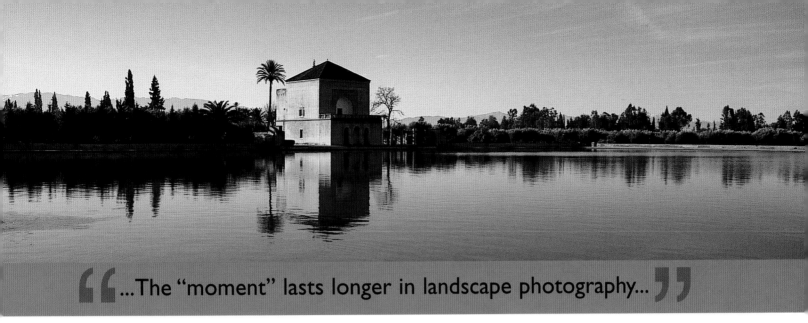

> **...The "moment" lasts longer in landscape photography...**

Finding the best moment

Landscape photographers talk about capturing the moment, when all the elements are illuminated perfectly. In landscape work, the "moment" lasts longer than with other kinds of photography. Light seldom changes so fast that you can't take several frames before it alters. Even with a view camera, it is usually possible to expose at least two sheets.

Good light usually means bad weather. I was out shooting with my Ebony view camera and 75mm Rodenstock lens. It rained, and the wind made my tripod bob around like a sail. Nevertheless, I took two frames that are among the best I have ever taken. The reason was the non-existent contrast. The rain had caused the river to rise—and in spate it was truly dramatic. As a bonus, the bad weather had also kept other visitors away.

Using a graycard

Choose your graycard carefully. I used one that had a sheen, and in certain lighting it was highly reflective, causing underexposure. For shooting on the coast—notoriously difficult for metering values—I use a Kodak graycard, which has a superior matt finish.

To use a graycard, position it where there are no shadows, brightly colored reflections, or glaring highlights, in front of and close to the subject. Assuming the sun is the main light source, and is behind or above the camera, aim the card at an angle between them. In overcast conditions, use the brightest area of the scene as the main light source. However, when metering from the card, make sure the card receives the same level of illumination as the main area of the scene. The best type of meter to use with a graycard is a spot meter.

above ► **Menara Pavilion, Marrakech, Morocco. I shot this on 35mm with a view to using it as a horizontal panoramic crop at a later date. I think it works fantastically well as a panorama. Pentax MZ5n + 28–70mm zoom on Velvia.**

Modifying natural light with filters

There is no doubt that the drama which light creates in the landscape can be modulated by the judicious use of filters. If you sell gallery prints, then you need to learn to control light. I sell a lot of intimate landscapes where the sky is often absent. I rely on soft, diffused light to make my pictures work. For instance, the dusky interiors of a tropical rainforest or an oak wood in spring. However, if I shoot a grand scenic, I often resort to a filter to alter color temperature or modify contrast.

Warm-up filters

I believe 81-series warm-up filters are essential, as are a good range of ND grads. All my lenses have either a subtle 81B warm-up filter or skylight filter attached to protect the front element and to imbue warmth to the scene. I also use a system holder by Lee. This allows me to use a range of filters (81A–81D, plus 85-series filters), three hard neutral density graduate filters (0.3, 0.6, and 0.9) and a soft ND grad (0.45). The Lee system allows me to alter the combination of these particularly useful filters.

Polarizers

The importance of polarizers is misplaced in my view. Now that I use Velvia, I no longer use a polarizer. This film is so vibrant and punchy that I don't think a polarizer is really required. Additional filters that I use are an enhancer that augments red/brown elements in a scene without affecting other colors, and a set of magenta filters.

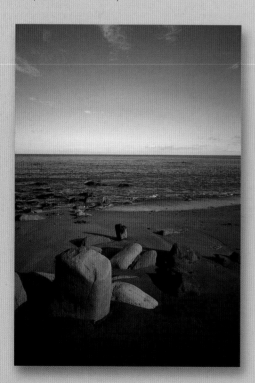

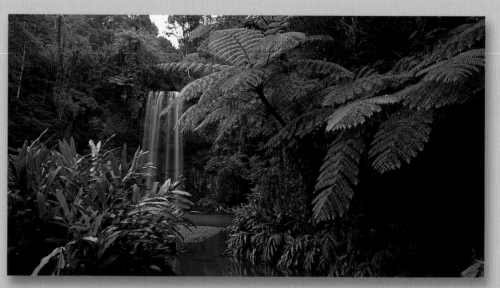

above ➤ **Millaa Millaa Falls, Queensland, Australia. Even an untrained eye could not fail to get the composition right on this image. Pentax 35mm, tripod.**

above ➤ **North Yorkshire coast, UK. Ebony SV45TE + aspheric 80mm Schneider Super-Symmar XL, f/22½ at 3sec.**

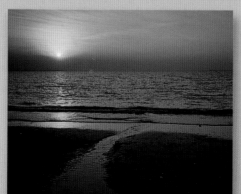

left ➤ **Sunsets are a feature of Australia's Top End. This view over the Timor Sea was taken handheld on a cheap Pentax compact.**

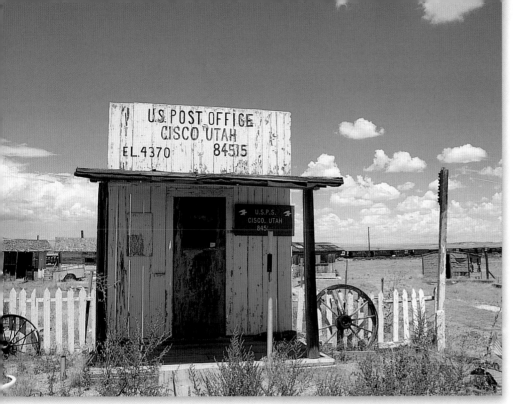

Neutral density graduated filters

Many professional photographers like ND grads. They are particularly useful for compensating film's inability to handle extreme contrast in a scene. If you have a sky that is much brighter than the ground, you have two choices: to meter for the ground and overexpose the sky, or to meter for the sky, or to average the two (sky and ground). In either event you need to underexpose the ground. To get around this problem, fit an ND grad to darken the sky and meter for the ground. In the final image, the grad should bridge the tonal gradient between sky and ground so as to look natural. I have always avoided colored grads such as tobacco, orange, blue, or magenta. Some images with color grads can look quite nauseating.

above ➤ **The sheer unlikeliness of some subjects makes them worthy for photography. There is a very isolated ghost town in Utah called Cisco. Since the railroad closed, it has become a classic extinct community overrun by tumbleweeds. This was the finest property in a very dead town. Having watched too many movies, I imagined a dozen winchesters pointed at me from behind the dilapidated timber facades. This building may be of today, but it has a distinct "Wild West" feel to it. Pentax 35mm kit.**

Selected filters for landscape photographers

Purpose/description	Filter designation	Required increase in exposure	Color temperature conversion
Warm up	81	2 EV	3,300 K–3,200 K
Warm up	81B	2 EV	3,300 K–3,200 K
Warm up	81D	B EV	3,700 K–3,200 K
Warm up	85C	B EV	5,500 K–3,800 K
Pale blue cooling	82	2 EV	3,000 K–3,200 K
Pale blue cooling	82A	2 EV	3,100 K–3,200 K
Neutral density graduated*	0.3ND	1 EV**	N/A
Neutral density graduated*	0.6ND	2 EV**	N/A
Neutral density graduated*	0.9ND	3 EV**	N/A
Polarizer	Polarizer	Variable	N/A

*Available as hard or soft graduation. Hard is the best option for general work.
**Damps down light transmission intentionally, therefore no increase in exposure is required.

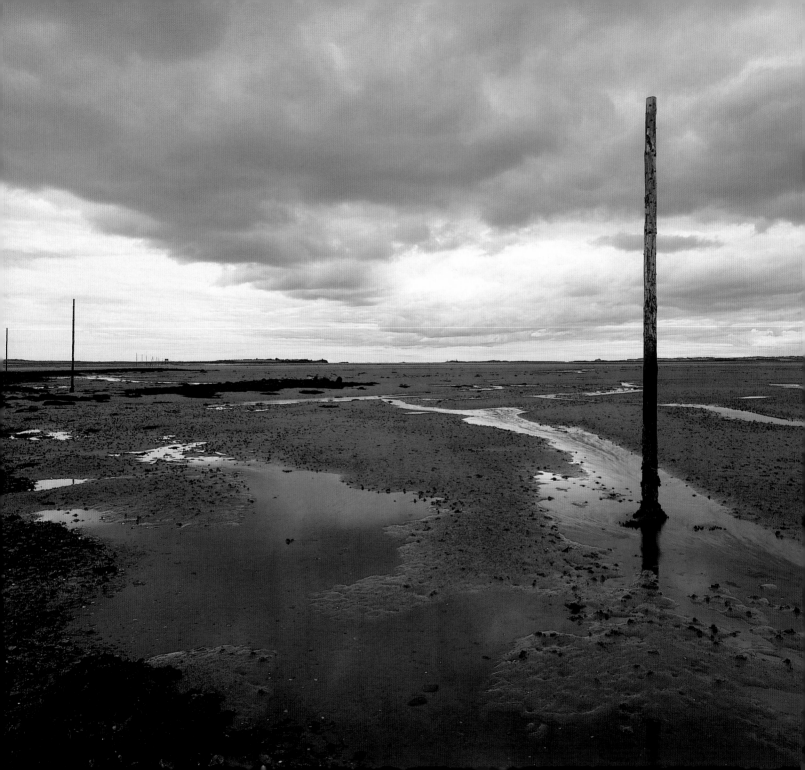

ND grads and large-format cameras

Another important, and often overlooked, use of ND grads is when using wide-angle lenses with large-format cameras. Many large- and panoramic-format systems that use extreme wide-angle lenses must be used with a matched concentric (or center spot) ND grad filter. These are very expensive, but can be essential in certain situations. If you are using a 105mm or 90mm lens on 6x17cm camera or a 30 or 45mm lens on the 35mm panoramic equivalent (Hasselblad X-pan), or if you use lenses of around 75mm or less on 5x4in, you need to employ a center spot ND grad filter to ensure even illumination. With extreme wide lenses, the light is projected over a wide area in an uneven swathe, such that the central portion becomes a hot spot of illumination with the corners exhibiting significant light fall-off. The center spot filter evens out this disparity in illumination.

I started using filters when I began using large-format cameras. Until then, I used a rangefinder—cameras that are not filter-friendly, as they do not permit TTL viewing, making grads in particular difficult to position correctly.

left ➤ **Virgin River, Zion National Park, Utah, US.** The sinuous Virgin River leads the viewer into this image as it funnels between steep mountains. **Mamiya 7II + 65mm lens on Velvia, tripod.**

below ➤ **Pelican Beach in Wyrrabalong National Park, NSW, Australia, provides a perfect sandy beach scene that demands panoramic treatment. Fuji GX617 + 90mm lens and Velvia. A ND center spot filter was used to ensure even illumination.**

left ➤ **Beal Sands, Northumberland, UK. One of the best ways to modify the image to suit your inspirational vision is to use carefully selected filters. This image was taken using a 0.3ND grad—a subtle filter that complements the natural lighting well. The pole was placed in the right third of the frame in accord with the rule of thirds. Ebony RSW + 75mm Rodenstock lens, f/32 at 1 second.**

Low light and reciprocity failure

This is an important area to consider if you shoot landscapes. Reciprocity describes the inverse relationship between camera shutter speed and lens aperture. Thus, an aperture of f/11 at 1/60sec gives the same exposure as f/16 at 1/30sec or f/8 at 1/125sec. In other words, to maintain a constant level of exposure when you reduce the shutter speed, you must compensate by opening the aperture (setting a lower f-stop number) and vice versa. This reciprocal relationship forms the basis of the clever algorithms that control our automatic cameras and handheld exposure meters.

Fortunately, under most normal conditions this reciprocal relationship holds up, and our various exposure meters can be trusted, bearing in mind the caveats regarding deviation from metered values for scenes that do not have average tonality based on an 18 percent gray scale.

Very short and very long exposure times, however, lead to reciprocity failure. When shooting scenic views at the very beginning or end of the day, you will inevitably have your camera on a tripod, combining a slow film such as Velvia with the smallest aperture possible—no larger than f/16, and possibly up to f/45 or even f/64 with a large-format camera. Add to this the

loss of up to 2.5 EV stops when using concentric ND center spot filters (as I do for my Rodenstock 75mm wide-angle), and exposure times can really drag on, affecting the normal reciprocal shutter–aperture relationship.

This phenomenon will also occur in dense woodland even at midday under a tropical sun. This was the case as I struggled around the Mossman Gorge section of the Daintree National Park in Queensland, Australia, with a tripod and Mamiya 6x7 outfit. I set my camera up at around noon on a bright but overcast day. Using my ultra-wide 43mm lens, I set up the tripod in deep, flowing water, pointing the

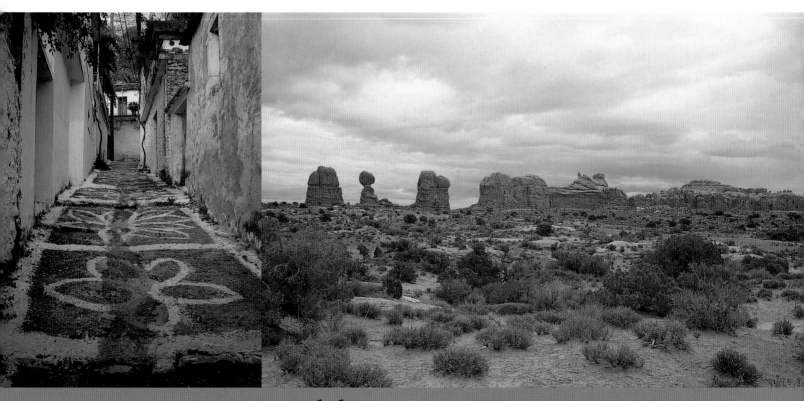

"This phenomenon is more common than you

1 ➤ Evening in an alleyway in Kastania, Greece. The muted light does away with the harsh contrast of the day, and makes for a pleasing classic Greek composition. GA645Zi on Velvia, f/22 at 0.7sec.

2 ➤ Rock formations at Arches National Park, Utah, US. I set the distant formations on the horizon against a menacing sky. Fuji GSW69III on Velvia, f/11 at 1/15 sec, tripod.

3 ➤ This joshua tree sits well against the surreal looking desert rock. The scene definitely works, but it always reminds me of a Flintstones cartoon. Mamiya 711 + 65mm lens on Velvia.

4 ➤ Stone wall, Swaledale, Yorkshire Dales, UK, early evening in spring. Ebony RSW + 75mm Rodenstock f4.5 Grandagon N, f/22½ at 1sec with front tilt on Velvia 120 film in Horseman 6x12cm back.

5 ➤ I used a map of Sydney, Australia to select the Royal Botanical Gardens as the best vantage point for the bridge and Opera House at sunset. Fuji GX617 + 90mm lens.

might think, occurring at the tail ends of the day..."

camera upstream to take in the marginal palms and foreground rocks and stones. The ISO 50 exposure was indicating 4sec at f/16. I bracketed up to 30sec to be sure of getting at least one perfect exposure of this magical scene. The best shots, however, were at 8sec and f/16—a full stop over that recommended. A similar story unfolded nearby where I shot the eerie buttress roots of the giant rainforest trees. Here 15sec at f/16 was required.

Many photographers might be inclined simply to open the aperture until they get a sensible shutter speed that falls back onto the normal reciprocal relationship between shutter and aperture. But life is not so simple—you will rapidly lose depth of field if you do this, and this is what makes this sort of photography successful—sharpness from near to far—especially when you print really big, as I do.

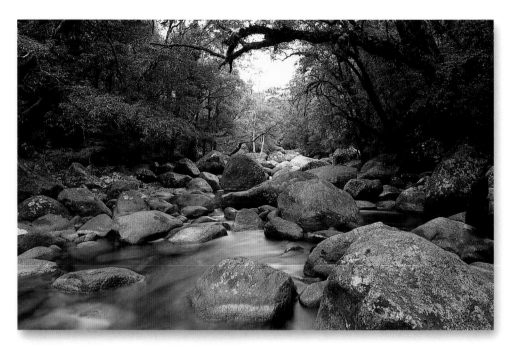

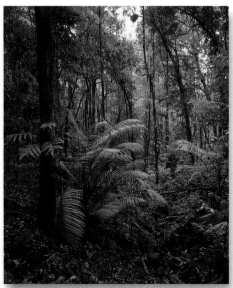

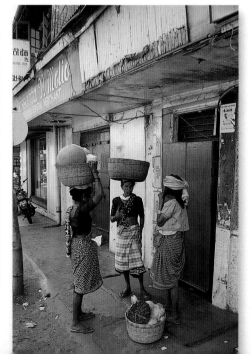

above ➤ **River rapids cascading down through rainforest scenery. Mamiya 711 + 43mm lens.**

far left ➤ **Deep inside the Australian rainforest. Mamiya 711 + 43mm lens. The extreme wide-angle lens helps to make a tapestry from a profusion of detail.**

left ➤ **The developing world offers fascinating subject matter for the landscape photographer, with street scenes full of character. Handheld Pentax SLR on Velvia.**

Right ➤ **Goosenecks of the San Juan River, Utah, US. Mamiya 7II + 65mm lens on Velvia, tripod.**

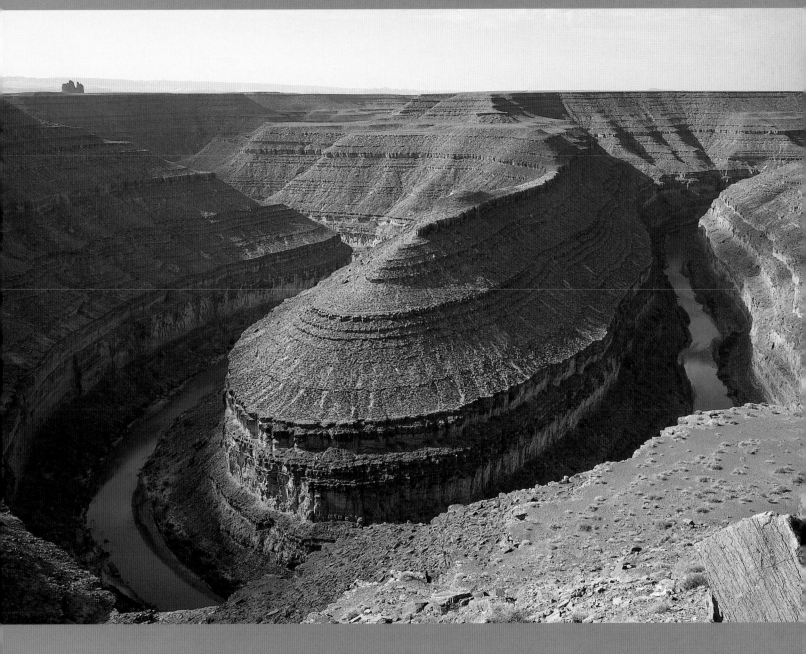

Film type	Color balance	Filter recommendation	Exposure increase
FUJI VELVIA [RVP]	1/4000 SEC to 1 SEC	NONE	NONE
	4 SEC	5M	+2 STOP
	8 SEC	7.5M	+1 STOP
	16 SEC	10M	+B STOP
	32 SEC	12.5M	+1 STOP
	64 SEC		NOT RECOMMENDED
FUJI PROVIA 100F [RDPIII]	1/4000 SEC to 128 SEC		NONE
	4 MIN	NONE	+2 STOP
	8 MIN	2.5G	NOT RECOMMENDED
FUJICHROME ASTIA 100	1/4000 SEC to 32 SEC	NONE	NONE
	64 SEC	NONE	+2 STOP
	2 MIN	NONE	+1 STOP
	8 MIN	NOT RECOMMENDED	
FUJI PROVIA 100F [RDPIII]	1/4000 SEC to 32 SEC	NONE	NONE
	64 SEC	5G	+2/3 STOP
	2–4 MIN	7.5G	+1 STOP
	8 MIN	NOT RECOMMENDED	
FUJI SENSIA 100 [RA]	1/4000 SEC to 16 SEC	NONE	NONE
	32 SEC	NONE	+1 STOP
	2 MIN	2.5R	+1 STOP
	8 MIN	NOT RECOMMENDED	
FUJI SENSIA 200 [RM]	1/4000 SEC to 32 SEC	NONE	NONE
	64 SEC	5G	+2/3 STOP
	2–4 MIN	7.5G	+1 STOP
	8 MIN	NOT RECOMMENDED	
FUJI SENSIA 400 [RH]	1/4000 SEC to 32 SEC	NONE	NONE
	64 SEC	5G	+2/3 STOP
	2–4 MIN	7.5G	+1 STOP
	8 MIN	NOT RECOMMENDED	

Film type	Color balance	Filter recommendation	Exposure increase
FUJICHROME 64T TYPE II	1/4000 SEC to 1/30 SEC	NOT RECOMMENDED	NONE
	1/15 SEC to 64 SEC	NONE	
	2 MIN	NONE	+2 STOP
	4 MIN	NONE	+1 STOP
FUJICOLOR NPS 160 PROFESSIONAL [NPS]	1/4000 SEC to 1 SEC	NONE	
	2 SEC	NONE	+1 STOP
	10 SEC	NOT RECOMMENDED	
FUJICOLOR NPC 160 PROFESSIONAL [NPC]	1/4000 SEC to 1 SEC	NONE	NONE
	4 SEC	NONE	+1 STOP
	16 SEC	NONE	+1 STOP
	32 SEC	NOT RECOMMENDED	
FUJICOLOR NPL 160 PROFESSIONAL [NPL]	1/4000 SEC to 1 SEC	NOT RECOMMENDED	
	4 SEC	NONE	+1 STOP
	16 SEC	NONE	+1 STOP
	32 SEC	NONE	+1 STOP
FUJICOLOR NPH 400 PROFESSIONAL [NPH]	1/4000 SEC to 1 SEC	NONE	
	4 SEC	NONE	+2 STOP
	16 SEC	NONE	+1 STOP
FUJICOLOR SUPERIA REALA [CS]	1/4000 SEC to 1 SEC	NONE	NONE
	4 SEC	NONE	+2 STOP
	16 SEC	NONE	+1 STOP
	64 SEC	NOT RECOMMENDED	
FUJICOLOR SUPERIA 100 [CN]	1/4000 SEC to 2 SEC	NONE	NONE
	4 SEC	NONE	+2 STOP
	16 SEC	NONE	+B STOP
	64 SEC	NONE	+1 STOP
EKTACHROME E100VS	1/10,000–10 SEC (OKAY TO 1 MIN)	NONE	NONE

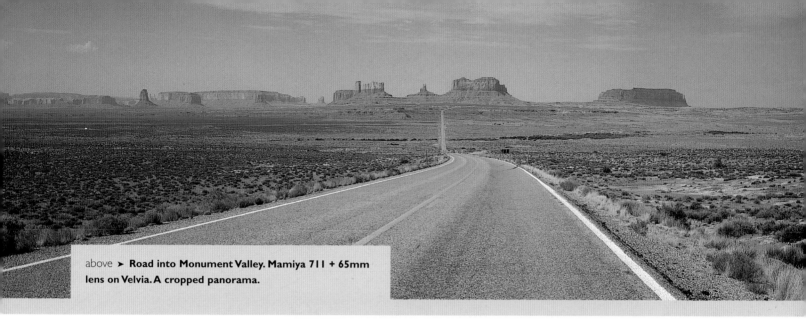

above ➤ **Road into Monument Valley. Mamiya 711 + 65mm lens on Velvia. A cropped panorama.**

Film brands and reciprocity

Dealing with reciprocity failure is a lot easier with a fully automated camera that stretches to 30-second exposures. My Pentax MZ5n has made light work of similar scenes in a small rainforest creek in Wooroonooran National Park, in Queensland. I set f/22 and noted that the exposure was already 20secs in the mid-afternoon light. I dropped to f/16 and bracketed until the shutter speed hit 30secs. The result was some excellent shots.

For those who do not favor my chosen films, the table on page 68 gives recommendations from Fuji regarding reciprocity characteristics for a good selection of their films—both positive chromes and negative prints.

While many landscape photographers favor Ektachrome E100VS reciprocity characteristics, others, myself included, also use Kodachrome 64. The recommendation for this emulsion is to add an extra stop at only 1sec. This film is not recommended with anything above 10secs. A red CC10 filter may help.

right ➤ **Taygetos Mountains, in the Outer Mani, Greece. The interest and detail at so many points in this image creates a three-dimensional vista that demands examination. Fuji GA645Zi on Velvia, f/22–32 at 3sec.**

Artificial light

Strange as it may seem, flash can sometimes be put to good use in landscape photography. This is particularly true at dusk, when ambient light disappears fast. Flash can be used in combination with long exposures to highlight a particular feature such as a rock in the foreground, a small tree—even people. When doing this it is always best to underexpose the flash element of the picture slightly. When shooting flowers as part of a broader landscape within the normal range of ambient lighting, a quick burst of flash can add punch to an otherwise dull scene.

Of course, you can throw extra light back into the scene using reflectors to enhance foreground illumination—perhaps a gold one to warm things up a bit. You could even use a torch on very long exposures to paint light over particular elements in the scene. A similar thing can be done with repeat bursts of your flashgun at different locations in the scene.

Light and mood

Quality of light in a scene creates the mood of a picture. For me, the mood and colors on a dull, wet spring day are hard to beat for intimate landscapes. Other photographers prefer the harmonious interplay of light and land in the low, colorful light at the tail ends of the day. Generally, we utilize frontlighting to render detail and color at their best, but despite the difficulty of metering it it is good also to experiment with both side- and backlighting, which produce bold pictures with a strong, graphic feel. Silhouettes at sunset are one such example.

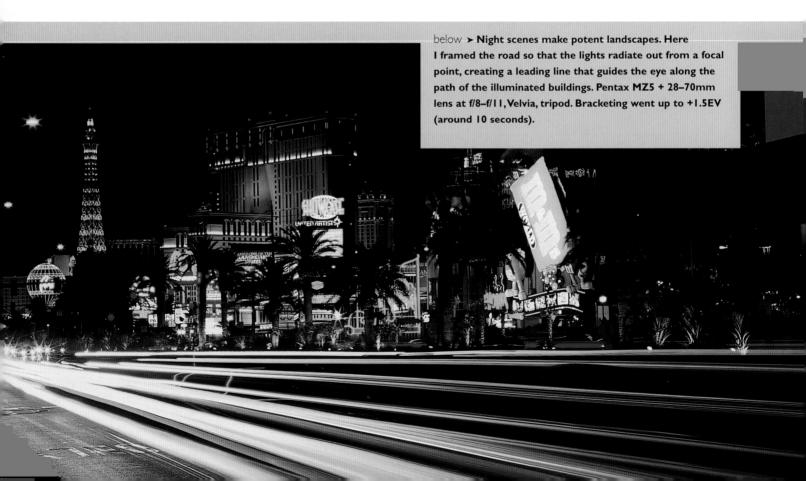

below ➤ **Night scenes make potent landscapes. Here I framed the road so that the lights radiate out from a focal point, creating a leading line that guides the eye along the path of the illuminated buildings. Pentax MZ5 + 28–70mm lens at f/8–f/11, Velvia, tripod. Bracketing went up to +1.5EV (around 10 seconds).**

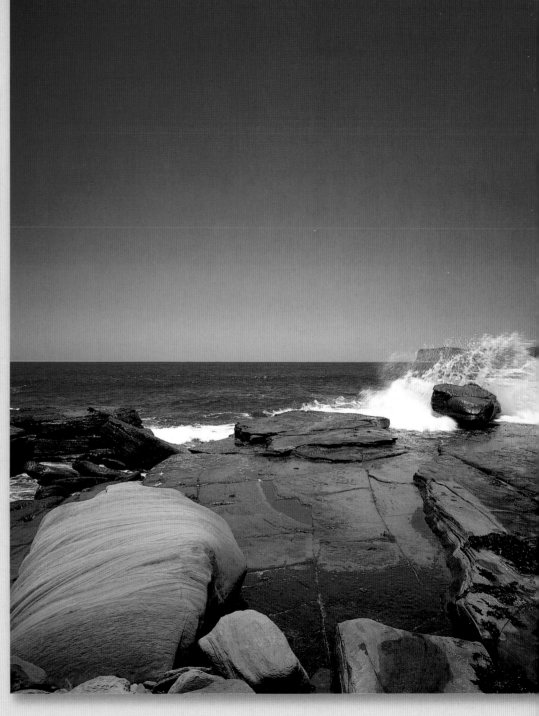

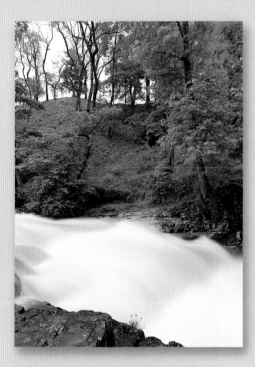

above ➤ **Stainforth Force, River Ribble, Yorkshire Dales, UK. This picture was taken at noon in May, yet the required exposure was 8secs at f/32 on Velvia Quickload. Ebony RSW + 75mm Rodenstock f4.5 Grandagon N and matched concentric ND graduated filter (loses 2.5 stops).**

right ➤ **This rocky beach between Terrigal and North Avoca, NSW, Australia is always quiet. This was shot over the Christmas period, but fortunately there was no-one to disrupt the natural harmony. Ebony RSW + Schneider 80mm lens on Velvia 5x4in Quickload film, f/22.5 at 15 secs. I used a little front axial tilt.**

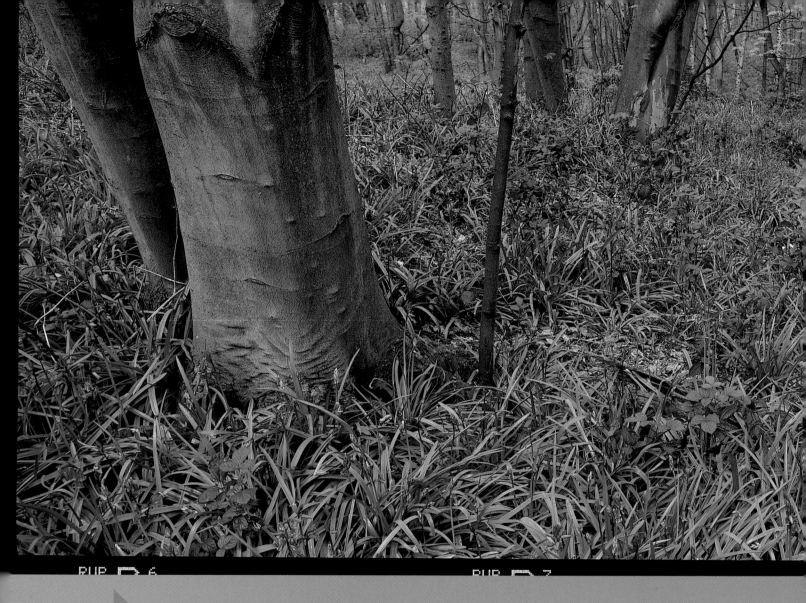

Setting the scene

"…shapes, textures, colors all combining

into a unique visual tapestry… **"**

Setting the scene

Orchestrating the visual elements

Every photographer has a reason for tripping the shutter. He or she has a vision. What separates the novice from the accomplished photographer is the interpretation of the scene. The novice will invariably be less focused, and point and shoot with little concern for the multitude of complementary or antagonistic elements in the scene. His eye is on a quick fix for the scene as a whole. With the same scene in mind, the professional examines its component parts. Trees have shapes, textures, color—all combining to yield a unique structure and visual tapestry. The combination of many trees can act in synergy, yielding a pattern that is attractive to the viewer, such as an elegant receding avenue of trees along a country lane, fruit trees in an orchard or multiple palisades of conifers in a plantation.

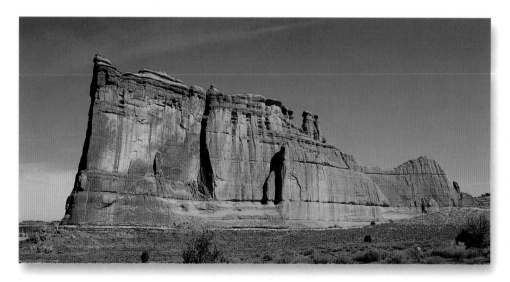

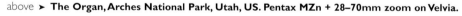

above ➤ **The Organ, Arches National Park, Utah, US. Pentax MZn + 28–70mm zoom on Velvia.**

top right ➤ **Much of what I shoot is planned. I saw this monolith and hiked over to Bell Rock in Arizona to shoot a few frames with my Pentax LX and 28mm lens on a tripod.**

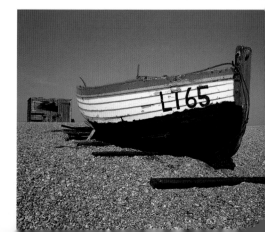

right ➤ **Dunwich, Suffolk, UK. Shoot a shingle beach on its own and you have a fairly boring picture. Add a colorful fishing boat and you have something that people might want to hang on their walls. Fuji GSW69III on Velvia, f/11 at ¹/₁₅th sec, tripod.**

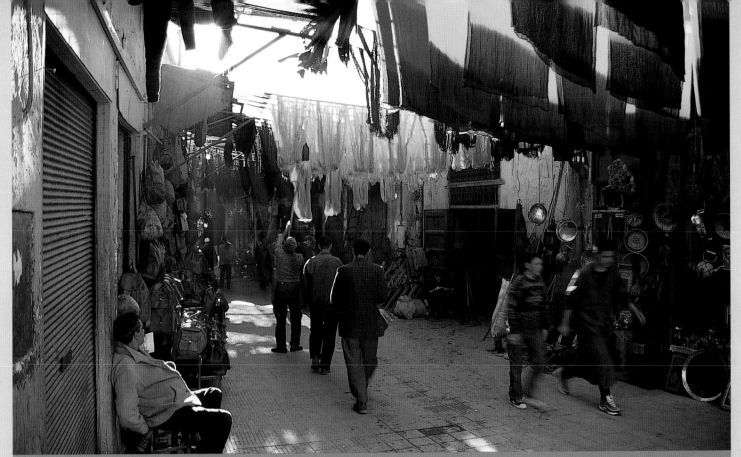

> " the colors of nature appeal to landscape photographers... "

Using color

Every child learns the spectrum of colors that make up visible light and how white light is split into its component parts by a prism, or by the effect of rain as it generates a transient rainbow. Photographers think about the transition from red to violet through orange, yellow, green, blue, and indigo in terms of color temperature. The color temperature scale is expressed in degrees Kelvin (K) which gives midday sunlight a value of 5,500K—a reference value to which all daylight-balanced films are indexed. At the orange-red end of the spectrum, the color temperature is warm—think sunsets and low, late afternoon light that rakes across the landscape (3,000–3,500K). The warm reds, oranges, and yellows generated by nature appeal to landscape photographers in particular, as these colors transform our world into a kaleidoscope that shows it at its most entrancing.

above ➤ **Marrakech, Morocco. Some pictures work because they reflect the archetypal view of a place we all have in our mind's eye. The image I had of Marrakech was one of colorful silks hanging out to dry in a souk alleyway. Achieving this mental image was thus one of my primary objectives on a trip to Morocco. Pentax MZ5n + 28–70mm lens on Velvia.**

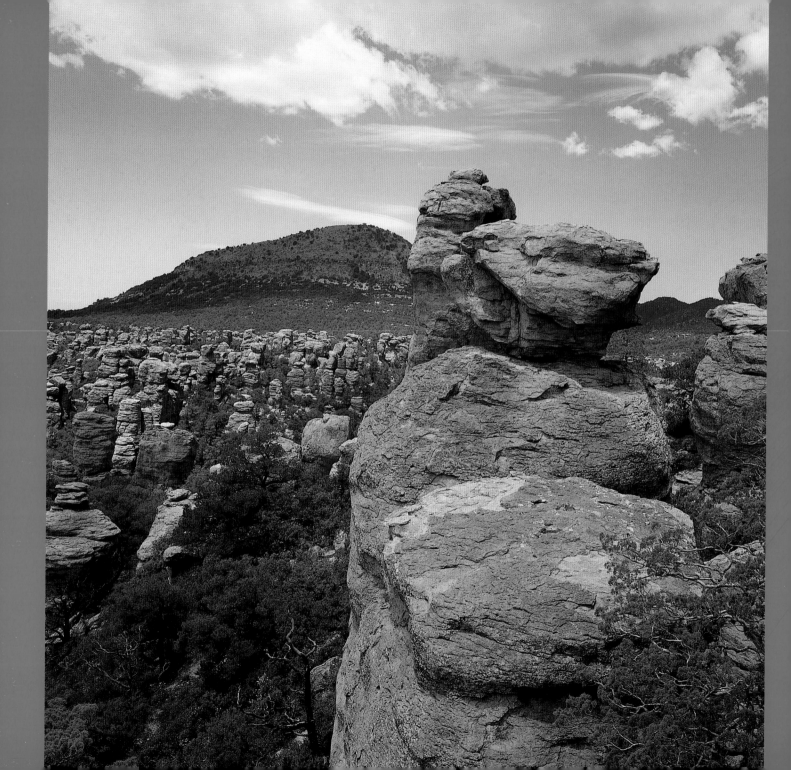

left ➤ **The Chiricahua Mountains, straddling the Arizona/Mexico border. Mamiya 711 + 65mm lens on Velvia, tripod.**

right ➤ **English bluebell woods. The wild garlic shows the importance of foreground interest and the flow of the flowers into the bluebells beyond also provides a leading line deep into the woodland. Pentax 35mm kit, long exposure, tripod.**

bottom right ➤ **A good sunset shouldn't require a fancy filter. However, judging the right exposure is not easy. Silhouettes need underexposure, while overexposure strikes a balance between retaining detail, but maintaining warmth. Fuji GA645Zi on Provia 100F, f/16 at 1/15sec (overexposed by +0.5EV).**

below ➤ **This isolated poppy is, to me, as beautiful as a whole field. Pentax LX + 100mm macro lens.**

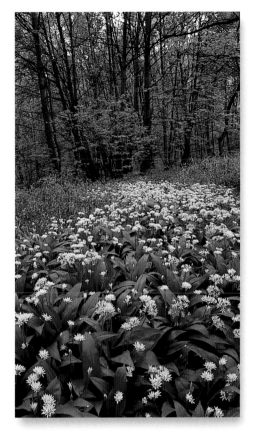

Using filters to enhance color

Many photographers mimic warmth of light with filters. 81A and B provide a subtle amber warm-up; 81C and D add even more warmth—indeed, care is required with these to avoid exaggerated effects. Special care is needed with 85-series amber warm-ups, which are very obvious in their filtration effect.

At the other end of the spectrum, blues evoke coolness. The blues of nature can be augmented with 80-series filters (a cloud-laden blue sky will be around 9,000–10,000K). I don't like too much blue in an image, but I have seen some magical dusk seascapes enhanced with 80-series filters. Warmth in an image, whether the natural end of daylight, or enhanced by filters, definitely improves visual appeal and saleability: if two images of the same subject are placed side by side, the warmer one would sell first.

When I started selling gallery prints, I included some of my very "green" subjects. The first few prints to sell were the ones of rainforest. Velvia is perfect for getting the best out of foliage. 81-series filters enhance light at the end and beginning of the day, while polarizing filters add to the effect of a blue sky.

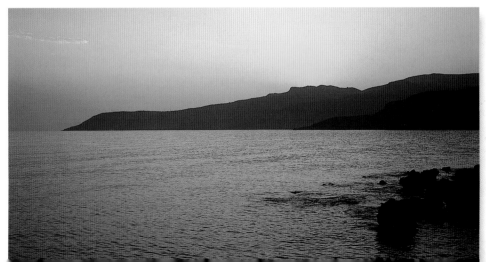

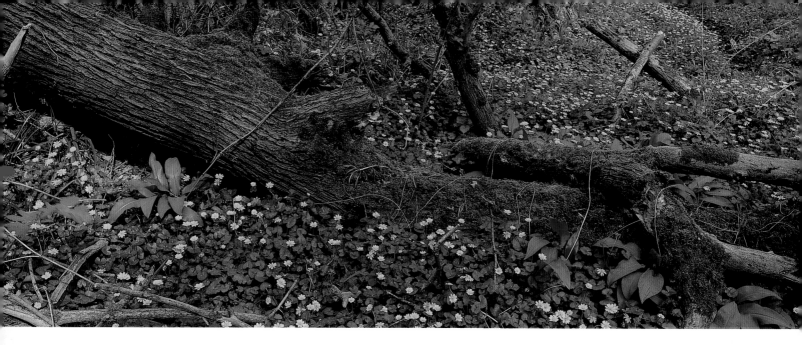

Color and composition

Color plays an important part in determining the overall mood of a picture. It can also play a role in the graphic design of an image. For instance, a lone scarlet poppy in a bland sea of dry grass, or the juxtaposition of purple bougainvillea or red oleander against a whitewashed wall, perhaps with a blue chair or colored door in the scene. If you come across such dramatically contrasting colors, use them to shoot strong, arresting graphics, as these have strong sales potential.

I once went on a trip to the Mani Peninsula, a beautiful region of the Peloponnese, in hot July weather. There were plenty of sunflowers and bougainvilleas, but the scene was always cluttered. Then I found what I was looking for in a village street: a door set in a white wall offset by a red oleander bush (see page 87). I find the easiest way to exclude extraneous distracting details from such compositions is to shoot macro, which makes it far easier to isolate color.

above ➤ **This decomposing tree trunk attracted me because it symbolized decay, while by contrast, the yellow spring carpet of lesser celandine symbolizes renewal. Fuji GX617 + 90mm lens on Velvia.**

right ➤ **I took exactly the same tack with this shot of the Washington Monument and perfectly juxtaposed stars and stripes. However, here all I used was a simple Pentax "point and shoot" compact camera.**

Using lines in composition

Avenues and palisades of trees can produce a visual thread—a leading line into the scene. There are many other ways to achieve this—for example, paths in a wood and stone walling are very useful. The lines of roads, paths, or rivers provide a three-dimensional perspective to the image, carrying the viewer's attention into and through the frame.

Every year, in England, as the bluebells arrive, I shoot in my local wood. Last time, I shot a path through the wood to try to emphasize depth. The leading line of the path does just what I had intended: it invites you into the scene. Stone walling in the Yorkshire Dales in the UK achieves the same effect. I used my Ebony RSW 5x4in

camera with a Horseman 6x12cm back (in vertical panoramic set-up) to shoot a dry stone wall receding onto the distant fells. The use of front tilt to emphasize foreground worked well to lead the eye off into the distance where a lone building stood.

In another image (page 100), the Colorado River acts as a thread to draw the reader through the red rock landscape of North Arizona. One of my favorite examples using leading lines is a shot of dilapidated walling leading toward the backdrop of the Taygetos Mountains (page 69). Shot on a rare dull day, the lack of contrast brought out all the detail.

above ➤ **North Yorkshire Moors, UK. An example of foreground interest—this large rock provides an anchor to the rest of the image. Ebony RSW + wideangle lens. F22 at ¹/₈ sec**

left ➤ **Crashing sea on rocks. This is one of my favorite digital images. I loved the colors in this scene and the strong visual composition, enlivened by the breaking waves. No manipulation was carried out afterward. 5 megapixel Canon G5 Power Shot.**

Foreground interest

More often than not, the success of a landscape photograph depends upon a foreground feature, such as a large rock, patch of flowers, or fallen log. In general, this is not the main subject, but is designed to reinforce the major component of the picture—perhaps a distant mountainscape or canyon. You need to balance foreground and distant subjects so that they augment the overall scene; it is not usually a good idea to make the foreground interest too dominant.

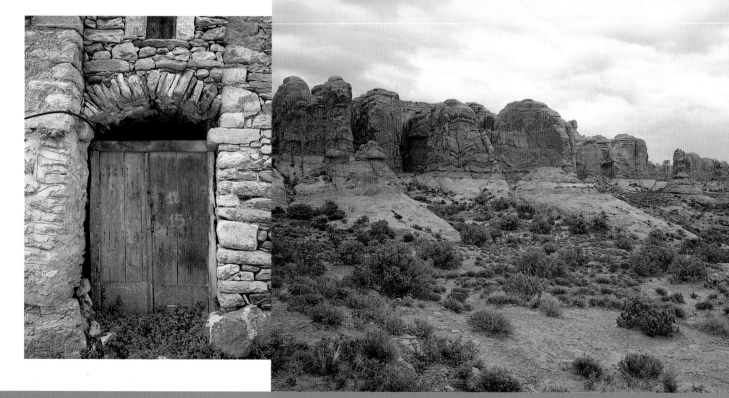

❝ The success of landscape photography depends

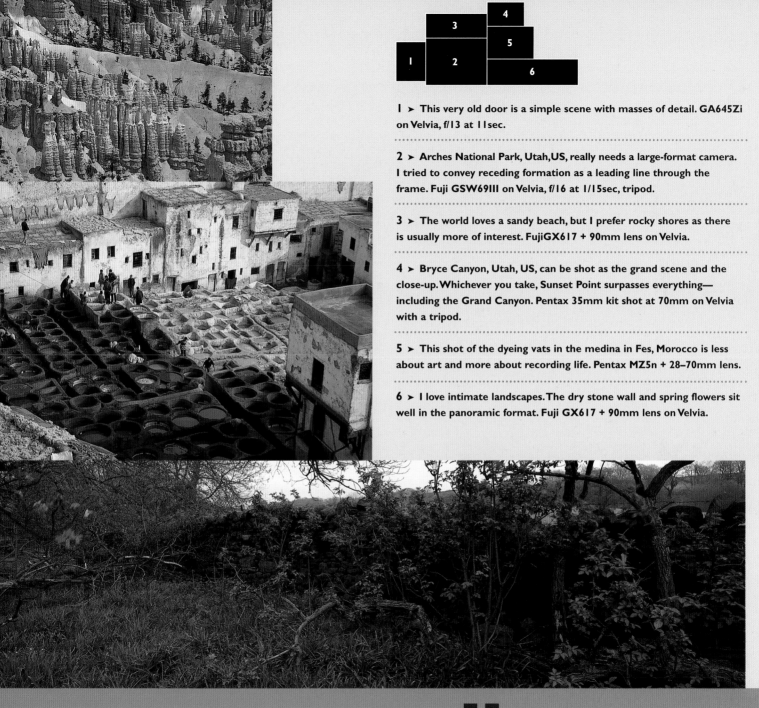

1 ➤ This very old door is a simple scene with masses of detail. GA645Zi on Velvia, f/13 at 11sec.

2 ➤ Arches National Park, Utah, US, really needs a large-format camera. I tried to convey receding formation as a leading line through the frame. Fuji GSW69III on Velvia, f/16 at 1/15sec, tripod.

3 ➤ The world loves a sandy beach, but I prefer rocky shores as there is usually more of interest. FujiGX617 + 90mm lens on Velvia.

4 ➤ Bryce Canyon, Utah, US, can be shot as the grand scene and the close-up. Whichever you take, Sunset Point surpasses everything— including the Grand Canyon. Pentax 35mm kit shot at 70mm on Velvia with a tripod.

5 ➤ This shot of the dyeing vats in the medina in Fes, Morocco is less about art and more about recording life. Pentax MZ5n + 28–70mm lens.

6 ➤ I love intimate landscapes. The dry stone wall and spring flowers sit well in the panoramic format. Fuji GX617 + 90mm lens on Velvia.

upon some kind of feature in the foreground. ,,

The dos and don'ts of good composition

Don't cut off the base of trees in any country scene

Don't shoot distant scenes with much out of focus foreground detail in frame. (Use a tripod and stop down to f/22 or less.)

Don't place the point of interest—the raison d'être—in the middle of the frame (although a few subjects do actually benefit from breaking this rule).

Don't place the horizon too close to the top of the scene, and avoid sloping horizons, especially with seascapes (I have yet to find a built-in spirit level that works well in this respect).

Don't include too much chaotic detail. Remember complexity need not be chaotic—arrange it in a way that is as organized as possible.

Do give the primary point of interest maximum impact—go in close or let it hold a healthy, balanced perspective with its surroundings.

Do add a person or animal to give a sense of scale in big scenics.

Do apply the rule of thirds. Used properly, this will generally give the most satisfactory and dynamic composition. Place your primary point of interest at a point that falls on a line one-third into the frame along either edge of the image. Which line you select will depend on the nature of the subject and the secondary features that are also contained in the landscape. Strong vertical features also work well if they fall on the vertical lines one-third of the way from either edge, while horizons are best on the horizontal line one-third of the way from the top.

right ➤ **This image of Delicate Arch, Utah shows the effect of light upon a scene. Once I had set up my Fuji GSW69III for the best composition of Delicate Arch that I could find, I shot the changing light from a low-angled sun 20 minutes before sunset, to the muted pink light that immediately precedes the night. The low-angled light picks out relief on the rocks, while the later shot exhibits alpen glow on the distant La Sal Mountains. If you want to know how good the Fuji 65mm wide-angle lens is, I shot the alpen glow image at almost full aperture (poorest resolution on most lenses), yet I have a 4ft print of it hanging on my wall. It is razor sharp even at this size.**

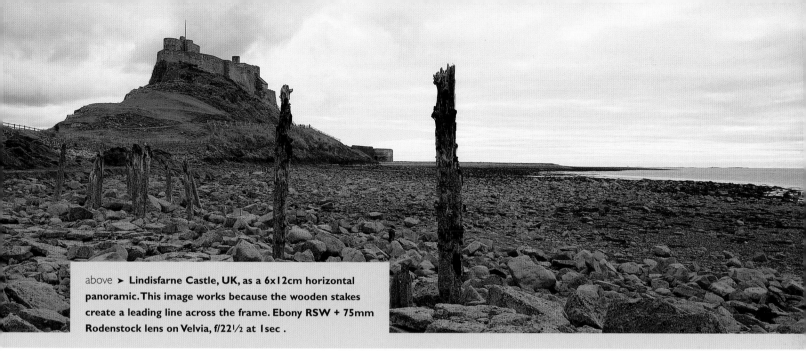

above ➤ **Lindisfarne Castle, UK, as a 6x12cm horizontal panoramic. This image works because the wooden stakes create a leading line across the frame. Ebony RSW + 75mm Rodenstock lens on Velvia, f/22½ at 1sec .**

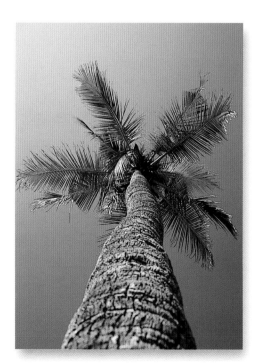

To add foreground interest, you need a good-quality wide-angle lens. 24mm on 35mm format is ideal. I also use 43mm on 6x7cm and 75mm on 5x4in formats. These give near-to-far sharpness when stopped down to f/22–f/32. It is important to remember that depth of field is proportional to focal length. While a 24mm lens on 35mm format gives the same wide-angle perspective as a 75mm lens on a 5x4in camera, the depth of field is dramatically less on the larger format. Fortunately, it is possible to get around this by employing front- or rear-tilt on view cameras. However, on 6x7cm roll film cameras this is not possible, and I use an ultra-wide 43mm lens (21mm equivalent on 35mm format) to circumvent this problem.

If your camera has depth-of-preview, you can evaluate the field of sharpness, although it is difficult to use this feature in low light. Despite this, modern autofocus SLRs are so good that you can usually rely on their focusing algorithms.

left ➤ **I employed an isolationist approach to get this shot of a coconut palm, fitting a wide-angle lens and pointing upward.**

below ➤ **The Blue Mountains. Plagiarism and landscape photography go hand in hand—the picture can come out as a clone of everyone else's vision. Fuji GX617 + 90mm on Velvia.**

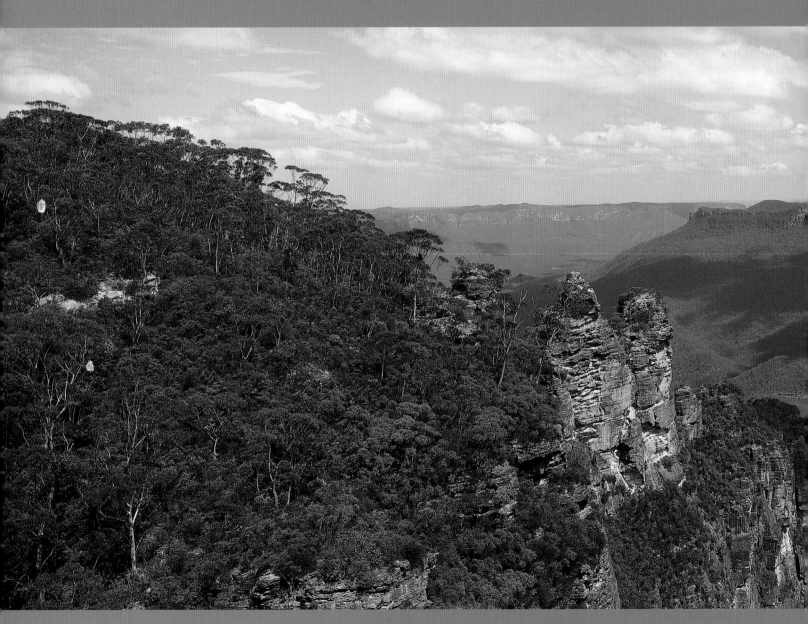

"Revealing a new facet in a well-known

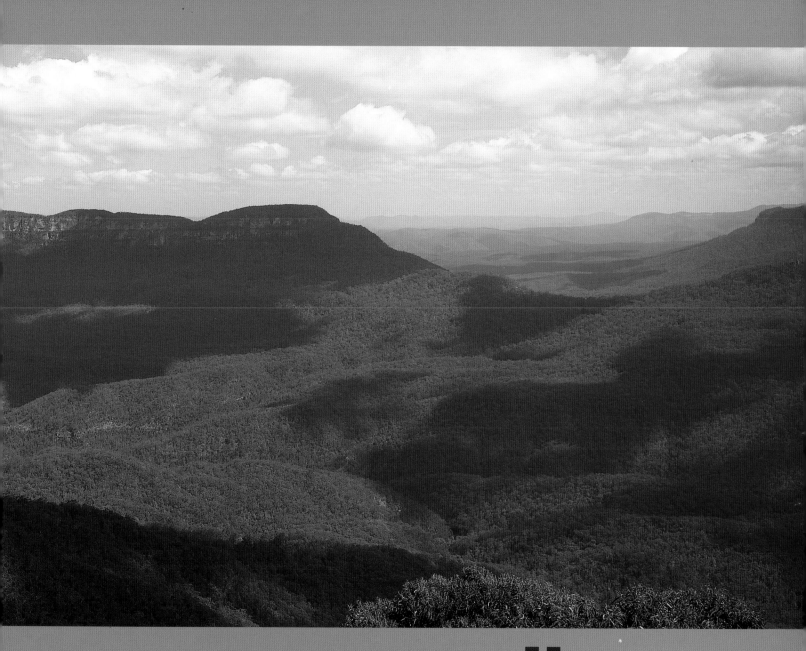

landscape can be fraught with problems of originality. **"**

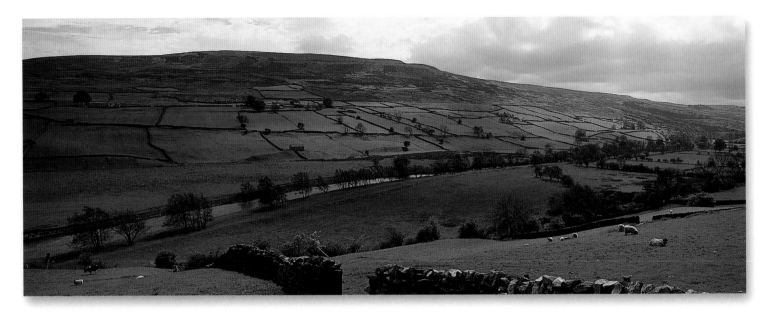

Patterns

The landscape is jam-packed with exquisite patterns. Let's consider other, more obvious designs—these are just some ideas. Up-close, ferns exhibit beautiful fractal designs. On a grander scale, large stands of trees can form a graphic pattern. Curvaceous sand dunes, ripples in sand, mud, or water also form repetitive patterns. Look out, too, for the geometric patterns of fields or dry stone walls.

To emphasize the majority of these patterns a telephoto lens will be best, as it homes in on the pattern, excluding any confusing, extraneous elements, and compresses perspective, giving a two-dimensional effect. You can also seek out the pattern caused by textures in bark or the striations in wind-blown grasslands.

above ➤ **Near Reeth in the Yorkshire Dales, UK. This 6x17cm panoramic shot shows how panoramics are just as good for big scenes of nature as for intimate ones. Even views like this need some foreground detail and in this case a handy wall provided the effect very well. Fuji GX617 + 90mm lens on Velvia, f/22$\frac{1}{2}$ at 3secs.**

right ➤ **Checkerboard Mesa, Zion National Park, Utah, US. This isolated monolith with its geometric pattern provides a graphic image. Mamiya 711 + 65mm lens on Velvia, tripod.**

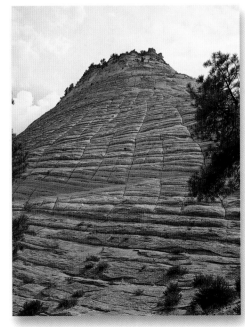

right ➤ **Trachila, Peloponnese, Greece. Strong graphics make interesting, yet simple, compositions. This well-worn door set in a whitewashed wall is set off perfectly by the oleander. With the bright sun and white wall, exposure had to be much increased to prevent gross underexposure. Fuji GA645Zi on Velvia, f/22 at 1/20sec (+1.5 EV) .**

bottom right ➤ **Going in with a close-up lens yields colorful, abstract designs. The microscope objective used here does not have iris blades, so by default you must shoot wide open. I used a grainier film than normal.**

below ➤ **Kincumba National Mountain Reserve, Australia. Standard Schneider 150mm lens on Ebony RSW camera on Velvia 5x4 inch Quickload f/32 at 1/2 sec.**

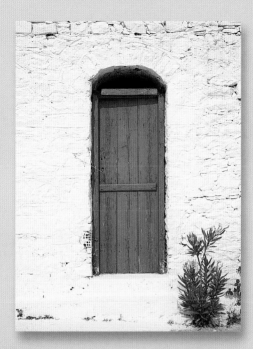

Detail

While strong graphics and a simple composition can be all that is required for a successful image, I generally prefer to see lots of detail—something to examine and to run my eyes over. For me an image should contain enough information to stimulate the imagination, but if there is a lot of detail in the frame, I like the elements to be arranged in a more or less harmonious order. Flat, two-dimensional images do little for the eye. I always make a concerted effort to orchestrate the various in-frame elements to produce a pleasing composition. For instance, I like scenes to be sharply focused, from close-up rocks to far-away cliffs. I also try to remove any incongruity; if I'm shooting an ancient packhorse bridge, I will exclude anything that reveals traces of modern life. I want to emphasize the landscape of which the bridge is a part—that is, it becomes a detail in itself.

"...by design, nature is full of enticing subjects full of detail..."

left and above ➤ **For extreme close-up, you need to shoot wide open, which produces a very soft image with little depth of field. To exaggerate this effect, I used a grainier film. The result is a series of soft, yet colorful, dreamy abstracts of nature.**

facing opposite, bottom right ➤ **North Yorkshire Moors National Park, UK. I believe that this 6x17cm Velvia transparency is on a par with some shots that I've taken in far more exotic locales. Exposures for the entire sequence were in the region of 45 secs at f/32.**

Using macro for detail

Nature is full of detail, particularly when viewed close-up. It is sometimes easier to use a macro lens to arrange the petals and reproductive structures of a flower so that they convey a beautiful, yet infinitely complex and detailed composition than it is to arrange the elements of a landscape image successfully. Few people are familiar with the macro world, and it provides an exciting challenge for the landscape photographer.

Finding the balance

I aim to organize all the available elements so that plenty of detail is present, with everything balanced to create a pleasing composition. I do much of my shooting in the soft light just before, and immediately after, sunset, when detail is always carried better by the film emulsion. On my trip to the Mani, I wanted to shoot some olive groves. I looked out for a tree next to a bit of dry stone walling, and arranged the perspective to balance tree and wall. The carefully constructed wall adds detail and

left ➤ **This old Maniot tower house in the mountain village of Kastania, Greece has a dark history. I shot it as day mutated to night, in a bid to try and catch the moodier side of the building. GA645Zi on Velvia, f/22 at 2sec.**

below ➤ **Majorda, India. A fishing boat returning with its catch. Pentax SLR on Velvia, tripod.**

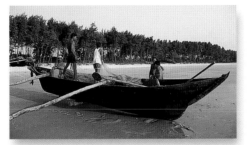

contributes to the overall rustic appearance. I ended up with a picture that is simple but that has plenty of interesting detail (see page 112).

At the same time, unwanted detail has to be avoided. I was keen to shoot some of the unusual Maniot tower houses of this austere region. In Kastania, the intrusions of modern life around the tower house meant the best approach was to shoot up at the tower. This led to a stronger, more graphic composition. It had less detail than I would have liked, and little context, but this was preferable to the unwanted detail of incongruous modern intrusions. Learn to recognize what detail to include, and what to exclude. Select details that absorb the viewer's attention rather than distracting from the main point of the picture.

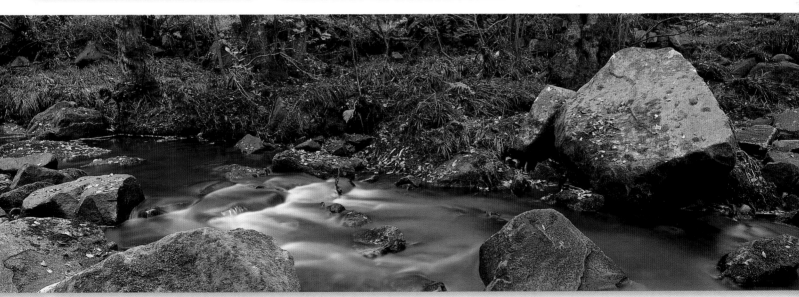

Evoking emotion

Advertising photographers know all about this ethereal concept; shoot an aquamarine sea gently lapping against a margin of golden sand that is delicately shaded by a palisade of coconut palms, and what do you have—a portal for spiritual access to a place where most of us would rather be. And you've sold a picture.

General landscape photography is not that different. The successful landscape photographer will, similarly, always attempt to create an image that is attractive to the viewer. He or she will juggle the composition to produce a scene that is as emotive as possible. If it's successful, any audience is likely to want to go see the place for themselves, either to experience the wilderness first hand, or to reproduce a similar photograph themselves. Seldom are two images of one place the same; time of day, year, and the weather all conspire to produce a unique signature to a location. So don't worry about plagiarism—originality is likely to be implicit in most pictures that you take, even if they are taken from familiar viewpoints. And, in any case, it serves you well to have a stock library of images that present familiar views of well-known locations. You never know when one of these images will be useful for editorial or other usage. These are really your "jobbing" images.

In fine-art mode, I am immune to "holiday brochure" imagery, but a sucker for a good Joe Cornish, David Muench, or Galen Rowell image that brings natural landscapes to life.

right ➤ **This enticing image works well because it has foreground interest as well as an alluring backdrop. Fuji GA645Wi on Velvia, f/19 at 1/20sec, tripod.**

Unexpected elements

As well as landscapes, I also photograph animals and plants in close-up. I think it is fair to say that I have sold an enormous number of close-ups for editorial use because they are so unusual. Luck, tenacity, knowledge, and a good measure of eccentricity go into successful shots of this kind.

Nature shots that show people something new will always fascinate, particularly if it is something they would never realistically be able to see for themselves, such as a rattlesnake head-on, or a moth or bee frozen in flight. Even flowers shot in close-up take on a complexity and beauty that goes beyond that seen by the naked eye. This new perspective on a familiar subject enhances saleability, and should make your images more viable for editorial use, especially if you can add a package of words to go with the pictures.

above ➤ **Katandra Reserve, near Terrigal, NSW, Australia. Look for the unusual in a scene. The roots of this rainforest tree have engulfed a large boulder as if they were a gnarled hand. Fuji GA645Zi on Velvia and bracketed toward a longer exposure to compensate for reciprocity failure.**

right ➤ **Strictly speaking, this shot of an Arizona barrel cactus is an environmental portrait, but it also symbolizes the Sonoran Desert landscape, where it was photographed near Tucson. To me it is half landscape and half portrait. Pentax MZ5n at the wider setting of a 28–70mm zoom, with a burst of fill-in flash to add to the already glorious colors of the cactus flowers.**

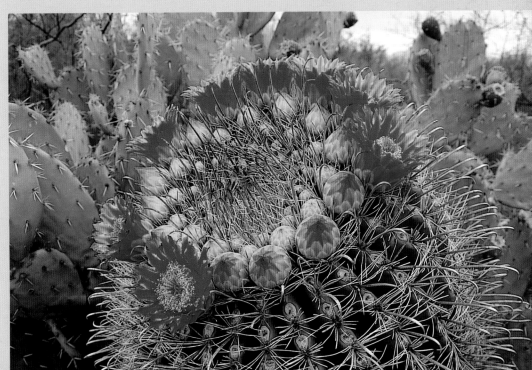

Making your photography work

and a desire to succeed. "

Making your photography work

Getting some perspective

It's a simple notion: you have a camera, you enjoy nature and the great outdoors, so why not sell some landscape pictures to make a bit of extra money? Undoubtedly this is a great idea. However, while you may be a competent photographer, you should most definitely think twice before giving up the day job.

Those that have made a success of doing this are an elite group of consummate professionals who work in a highly competitive marketplace. For many, I have no doubt that long hours and frustrations involved in doggedly achieving some degree of success may well have eroded away

the more pleasurable facets of landscape photography—but that is the trade-off when you make a living from the thing you love.

Whether professional or amateur, to succeed you must be a driven individual with an enduring passion for the photographic process, and you must have the inner vision to create consistently good, sometimes brilliant imagery. You need to have total empathy with your subject, absolute focus, and a desire to succeed. For many who do this for a living, photographing the natural world is like an addiction: it is all-consuming, and dominates daily life. It produces a unique pathology in which determined, obsessive

behavior overrules family life. For instance, in 90-degree heat, you drag your family 1,500ft up a steep goat track to get a better photographic perspective on a gorgeous maquis-fringed mountain valley. You know that they will decide to spend the following week on the beach, leaving you the hire car to explore deep into photographically unchartered countryside. You need this sort of ruthless dedication to succeed.

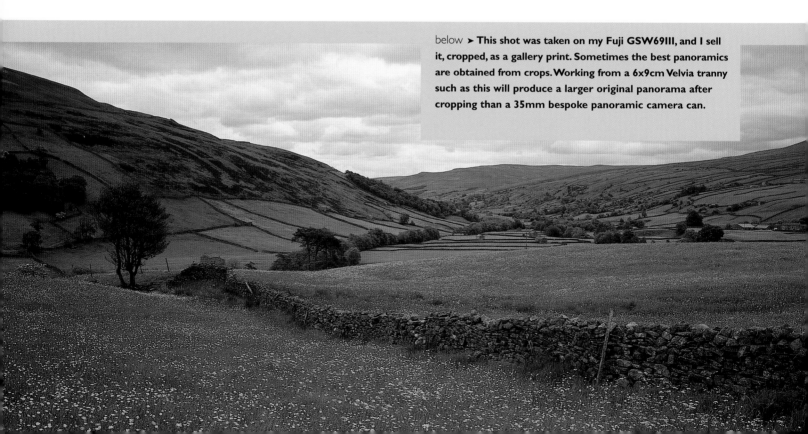

below ➤ **This shot was taken on my Fuji GSW69III, and I sell it, cropped, as a gallery print. Sometimes the best panoramics are obtained from crops. Working from a 6x9cm Velvia tranny such as this will produce a larger original panorama after cropping than a 35mm bespoke panoramic camera can.**

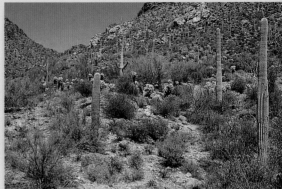

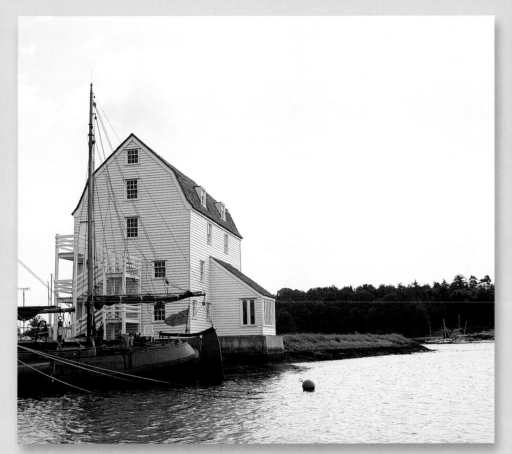

Developing your own career path

My photographic perspective has changed over the years. I started with a 35mm camera, shooting every aspect of nature. Eventually, I made the transition from photographer and naturalist to creative nature photographer, thinking more about photography as a creative process that emphasized in the best way possible the creatures I was shooting. I shot them from within their own world, not mine. Nature was in its context. Eventually, I sold the pictures and words about them as a package, and thus was borne my first book, *Photography for the Naturalist*.

above ➤ **This tide mill, at Woodbridge, Suffolk, UK, was bathed in a soft, muted light. The mill occupies a critical position in the frame that obeys the rule of thirds. Hasselblad + 80mm lens on Velvia, tripod.**

top right ➤ **This archetypal desert image typifies the Saguaro West, National Monument, US. Part of landscape photography is to record an image that matches the mind's eye view you have of an environment. This image is both how I imagined the place beforehand, and how I wish to remember it afterward. Pentax 35mm kit, Velvia, tripod.**

Today, my brand of photography has changed. My aim is to glorify nature with images that are dramatic, beautiful, and beguiling, and my efforts have moved inexorably toward landscape photography. My objective is to produce the best image quality in terms of composition as well as in tonal range and sharpness. As a professional biologist, I have no illusions about human impact on the landscape—I just hope that we don't burn our bridges as far as sustaining a self-regulating planet is concerned. I do know that, in addition to making my living from the thing that I love, my perspective on photography is to highlight, as best I can, what is left of our beautiful natural world. A stunning image of the countryside can change the way people see things. So why not try to earn a few extra dollars selling images that might just change the way people see the world?

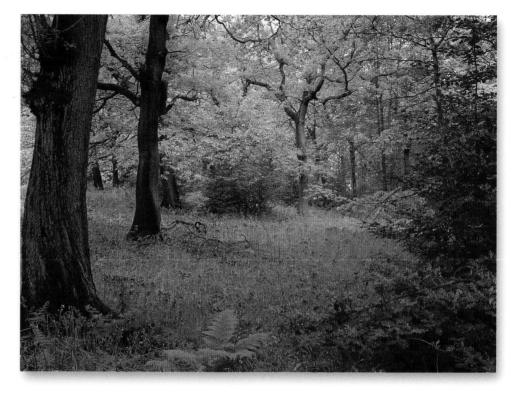

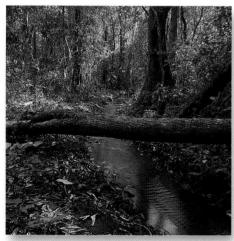

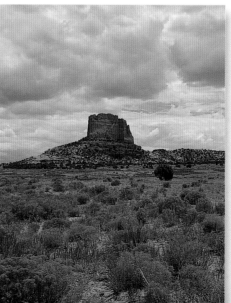

above ➤ **Bluebell and fern. Sony Cybershot P72. This camera has less control than the Canon G5, but can produce outstanding results, providing you don't want to reproduce large prints. I shot the fern as foreground interest.**

left ➤ **Square Butte, Arizona. Pentax MZ5n + 28–70mm lens on Velvia, tripod at f/16 on aperture priority with an extra half stop dialed in to compensate for the brightness.**

far left ➤ **Tropical rainforest, Western Ghats, India. Fuji GA645Wi on Velvia, f/13 at 1.5sec (+1EV), tripod.**

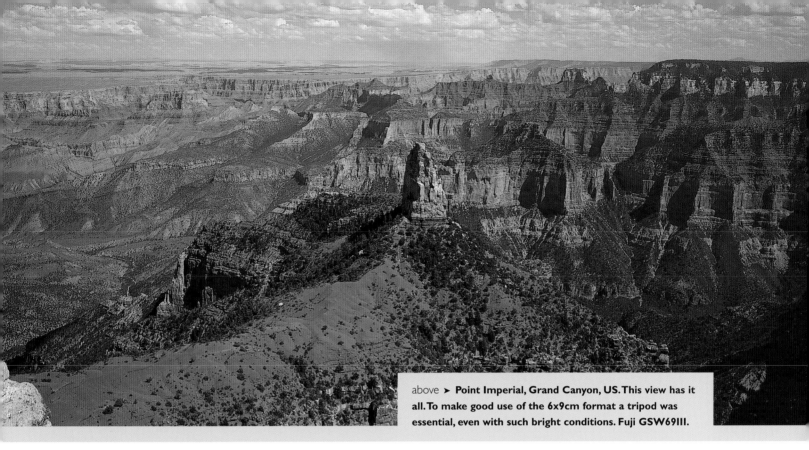

above ► **Point Imperial, Grand Canyon, US. This view has it all. To make good use of the 6x9cm format a tripod was essential, even with such bright conditions. Fuji GSW69III.**

Choosing your subjects

You should not be overly prescriptive in your choice of subjects. If it captivates you, shoot it—it will captivate others. However, it helps if you can develop a style that you make your own personal signature. In doing this, you will learn to think about a prospective shoot before you ever get into the field. When I travel, I buy as many detailed guidebooks on an area as possible to get a feel for a place. This helps me draw up a target list of definite and possible subjects and also to decide which equipment to take.

The other thing I always do is to leave space in my suitcase on the return journey for books, leaflets, and maps that I buy in the country I am visiting. The best information about an area is almost always obtained locally. In particular, look for local small press publications on the subjects of history and nature, as well as hiking maps. Doing this will put you in a unique position to add words to your pictures back home, as well as making you privy to information that will help you identify and locate photogenic subjects in out-of-the-way places off the tourist trail.

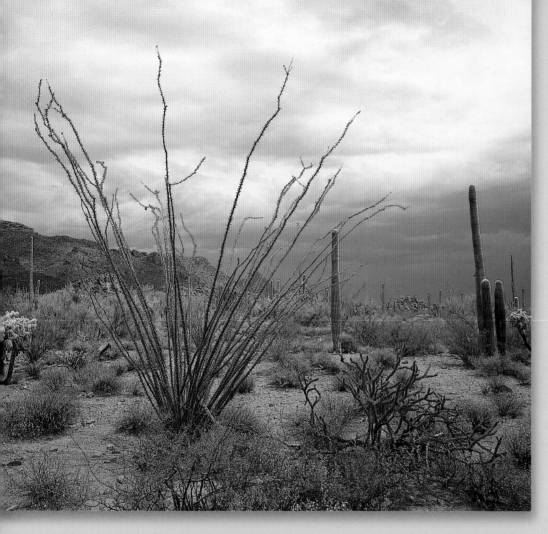

Pre-planning

When I have the luxury of a car for transport, I invariably opt for either 5x4in or panoramic formats. These are heavy items and not easy to use abroad with current airport restrictions. Nowadays, my domestic photography is almost exclusively performed on these formats.

When you are out in the field, scout around an area before you go out with your camera. I usually carry a compass so I can judge where the sun will rise or set to predict which features of a landscape will be illuminated or in shadow at a particular time of day. I also like to find and isolate elements of the landscape that might be central to a prospective image—in other words, to identify the lynchpin that is the reason for taking the picture. I then wander around, placing this lynchpin element back into the broader landscape from all angles until I find the one that suits both the overall scene and the main element itself. The land may communicate significance in the texture and direction of a rustic wall, or it may be the pattern of clouds in the sky. However, more likely than not, it will be the juxtaposition of different elements, which, when organized appropriately, simply look good.

Developing the right attitude

Having the appropriate professional attitude in executing your photography is an important point. Aspiring landscape photographers all dream of achieving the eminence associated with *National Geographic* photographers. However, you should always consider the ethics and risks associated with getting the image you are after. How far—if at all—should you intrude in people's lives, or risk your own safety? For instance, recently I wanted to shoot a seascape with rocky foreshore and ancient castle ramparts all in frame—a potentially outstanding image.

above ➤ **Ocotillo, an unusual desert plant has been used as an anchor for this desert scene, shot in drizzle at almost 100 degrees. Mamiya 711 + 65mm lens on Velvia, tripod.**

facing opposite, bottom ➤ **Temperate woodland in early fall, West Yorkshire, UK. I sell this favorite picture as a gallery print, and have it hanging on the wall at home. Fuji GX617 + 90mm lens on Velvia.**

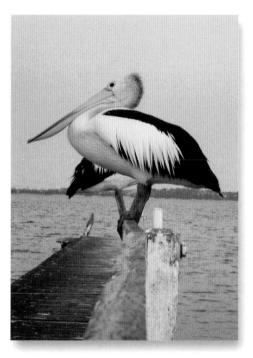

left ➤ **Pelicans at Chittaway Bay, NSW. Taken with a Sony Cybershot P72, this was a quick grab shot on my way home.**

below ➤ **Journalism, art, or landscape—I'm not sure how to categorize this 35mm image depicting Mormon propaganda on a roadside in Utah, but it is fascinating.**

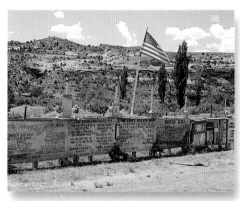

In order to get the composition right, I had to climb over a safety fence and balance on a cliff edge high above the shore. I probably was quite mad, and wouldn't advise anyone else to do what I did. However, I'm sure that many of the world's best landscape photographers have, like me, taken the odd risk or bent a rule to get a picture. But always weigh up the situation first. I am always courteous to people who may be involved in my photographic endeavors. I never trespass or put others at risk. No matter how much I want to shoot a colorful local character in the most perfect setup imaginable, if that person refuses my request for a shot, I won't take it. If you want to be professional, you must apply responsible ethics to your work.

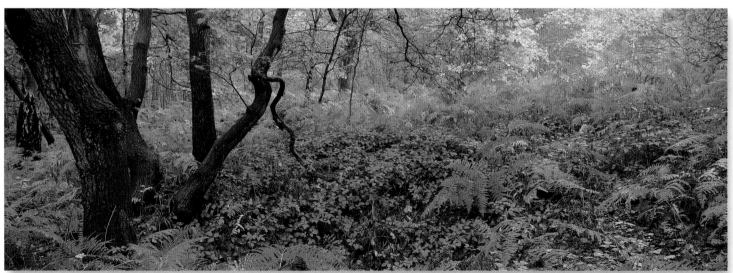

Where do you go from here?

For most budding landscape photographers, the editorial market is usually the first milestone in their career. This may consist of a simple one-off use of a picture in a minor local publication, or it could be a full-blown package consisting of a half-dozen images and a thousand words for a travel magazine. You could receive upward of a few hundred dollars from a reputable publisher for such a package, although rates are variable. Still, if you are establishing yourself, it can be a useful second income to help you build up your arsenal of cameras and lenses. If you can develop your reputation with consistently good work, you could well become a regular contributor to one or more magazine titles, covering a range of interests from the countryside to travel and specialist photography. It is worth developing relationships with editors or freelance writers for magazines you want to target, in order to make yourself better known. Words and pictures together sell better than either do on their own.

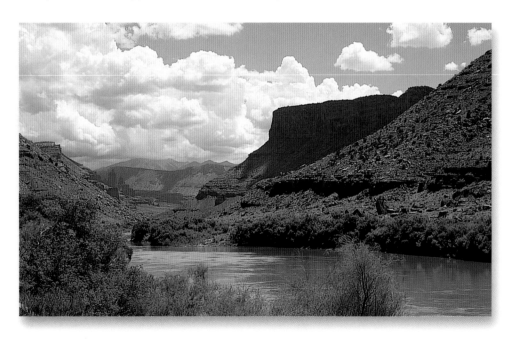

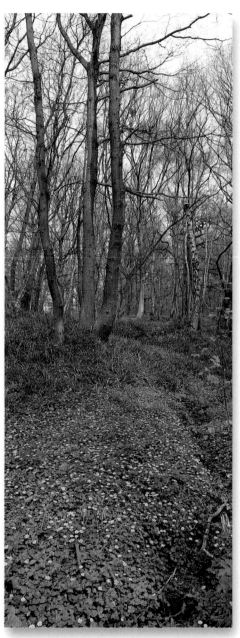

above ➤ **The Colorado River in the US leads the eye into this landscape. Pentax 35mm, tripod.**

right ➤ **The spring carpet of lesser celandine symbolizes renewal. Fuji GX617 + 90mm lens.**

opposite page ➤ **Cliff Beck from Buttertubs Pass, Yorkshire Dales National Park, UK. The diagonal cutting provides a line of balance, which holds this picture together. Hassselblad + 80mm lens on Velvia, f/8 at $1/8$th sec.**

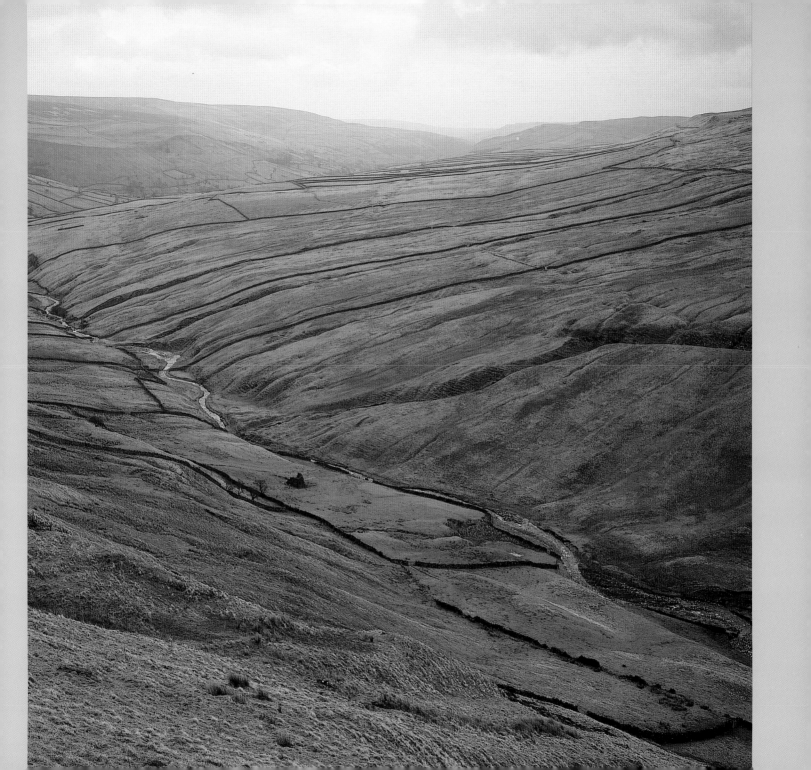

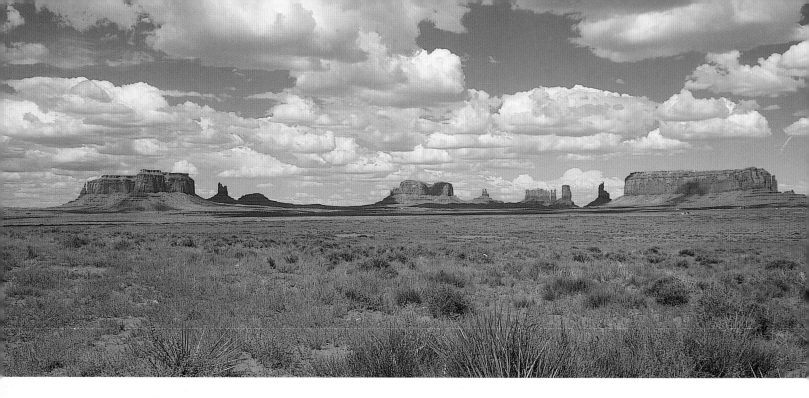

above ➤ **Monument Valley in the US is a
classic icon of our time made famous by film
director John Ford. So many photographers
have added to this, that it is near impossible
to show it in an original way without
plagiarizing. My attempt was to shoot from a
distance, and include a cloud-studded deep
blue sky. The effect is enhanced by using my
Pentax MZ5n in its panoramic mode. The
scene is immediately broken down into three
balanced elements—desert foreground,
dynamic sky, and a thin interface that blends
the two. Pentax Shot at around 50mm on a
28–70mm zoom on Velvia, tripod, f/16 on
aperture priority.**

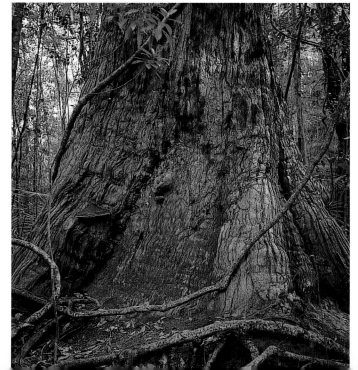

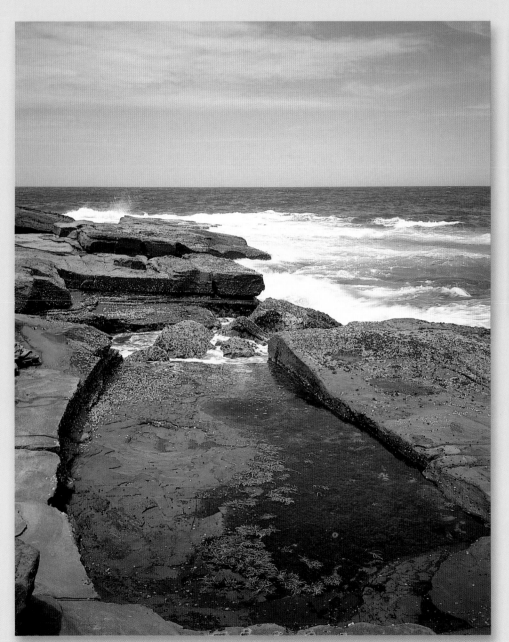

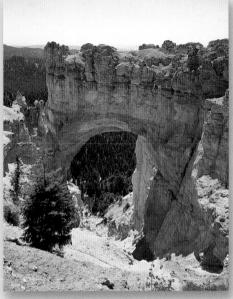

above ➤ **Natural Arch, Bryce Canyon, Utah. Mamiya 711 + 65mm lens on Velvia, tripod.**

left ➤ **A natural bathing pool, hewn by the elements, provides an excellent foreground anchor for this coastal scene. Fuji GA645Zi on Velvia, tripod.**

facing opposite ➤ **Turpentine tree, near Terrigal, NSW, Australia. Shooting in the rainforest requires manual exposure and a spot meter. The camera goes to two-second exposures on aperture-priority autoexposure, while dark rainforest scenes require small apertures with slow film. Fuji GA645Zi.**

Getting representation

You have two choices when selling your images: market them yourself or use an agency or picture library to represent you. If you go it alone, you don't have to pay agency commissions but you will miss out on the additional sales that a good agency with a global presence can offer. Successful picture libraries have a wider client base than you can put together. The downside is that your work will inevitably be viewed alongside that of other photographers, which means that it must be really good to stand out and to sell.

If you have a special expertise, you may be in a position to market your work without an agency. If few photographers supply your brand of work you will have a little niche to exploit.

Deciding on the publications to which you can make speculative submissions requires some research. This will include using the Internet, reading magazines, building up contacts, and talking to colleagues and other photographers for recommendations.

In the UK, an up-to-date list of all magazine and book publishers, along with photo libraries and literary agents, is published each year by A&C Black, entitled *The Writer's and Artist's Yearbook*. A similarly useful book is published by the Bureau of Freelance Photographers, entitled *The Freelance Photographer's Market Handbook*. This organization also produces a monthly newsletter which highlights the current needs of picture buyers. In the US, Writer's Digest produce a parallel tome, *Photographer's Market*. Often, though, your best source of information is your local magazine store, which will provide you with up-to-date inspiration for new ideas.

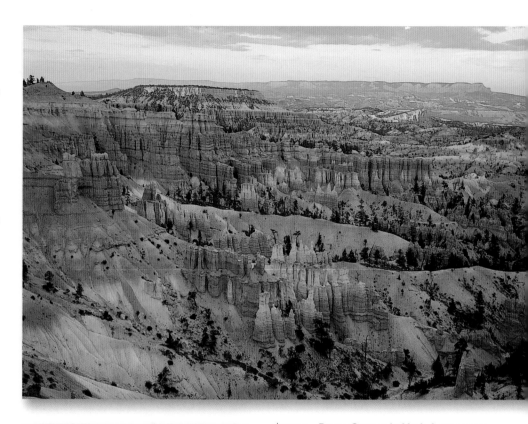

above ➤ **Bryce Canyon in Utah. I can never shoot this enough, particularly at sunset. I could spend the rest of my life taking pictures here. Mamiya 711 + 65mm lens on Velvia, tripod.**

left ➤ **Fishing boat, India. The way the bow of the boat cuts diagonally across the slide makes a powerful impact and enhances the overall graphic effect. This is the sort of image that could be used as a cover shot if required. Handheld Pentax MZ5n + 28mm lens on Kodachrome 64.**

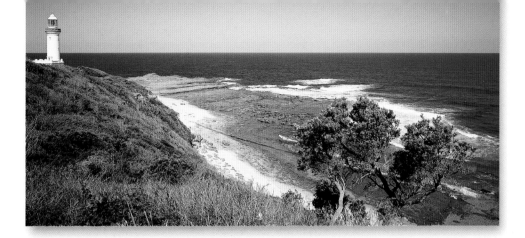

right ➤ **Norah Head Lighthouse north of Sydney, Australia. I shot it from a vantage point that permitted both 5x4in sheet film and 6x12cm roll film formats to be used on my Ebony RSW + Schneider 80mm lens. Velvia, f/22.5 at 15sec. In the bright light, I metered from a patch of grass.**

Tips for success

- Most publications publish two months ahead, so dispatch images that convey a sense of season at the appropriate time of year.

- Study a magazine's picture requirements and house style before submitting work.

- Target the appropriate editorial staff of your chosen magazine or book publisher.

- Ship your slides by an insured method of transit.

- Use the largest film format possible for the subject. For wildlife, 35mm is the only truly practical format with using film, but for high-end glossy magazines, medium- and large-format could give you the edge, particularly for landscape work.

- Submit slides for editorial use—unless you are a black and white photographer, prints are normally not required. Many publications now accept digital files. Investigate whether your target publication does this, and how the files must be saved.

- Never use glass mounts or overpack.

- Rather than sending duplicate transparencies, duplicate in camera at the time of original exposure whenever possible—quality is better and cost is less.

- Include a brief cover letter detailing the purpose and significance of the submission.

- Present your slide portfolio in a professional way. Place 35mm slides in transparent wallets; incorporate medium-format slides in card mounts.

- Keep meticulous records of your submissions.

- It is better to have slide submissions back by return post than have them collecting dust in an editor's office. If they come back quickly with a standard rejection slip, be grateful you can make a submission elsewhere.

- Label every slide with your contact details. If submitting to a photo magazine, include a label that details the subject and equipment used to make the picture. If submitting to a travel or nature magazine, give adequate details on the subject.

- Send only first-rate material. A few high-calibre slides are better than many more mediocre ones. Remember, first impressions count.

Making and selling prints

In addition to supplying magazine and book publishers, another way to make money from photography is to sell prints made up from your best transparencies directly to the public.

In some ways there is more satisfaction in doing this than there is in being published in magazines. This way you get to see tack-sharp enlargements of your work. It is also gratifying to feel that people regard your work highly enough to spend their hard-earned money on it.

There are many simple ways in which you can sell your work to the public, from the cheap and cheerful craft-market circuit, to local exhibitions you can organize yourself in appropriate venues (usually libraries, bars, cafés, small galleries, etc.). Of course, you can also set up your own website and sell your prints over the Internet, with facilities for making transactions built-in.

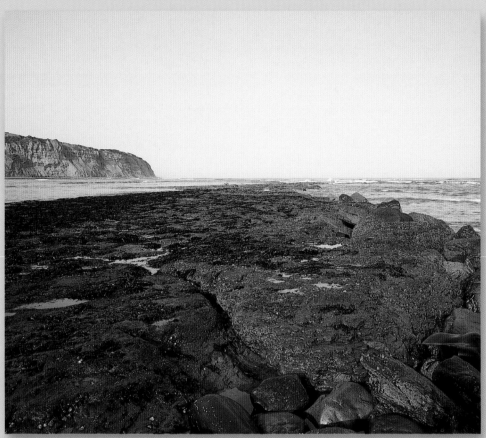

above ➤ **This rocky brig at Robin Hood's Bay, Yorkshire, UK was shot with a small aperture for maximum depth of field, keeping the whole scene in reasonable focus. Mamiya 7II + 65mm lens on Velvia, tripod.**

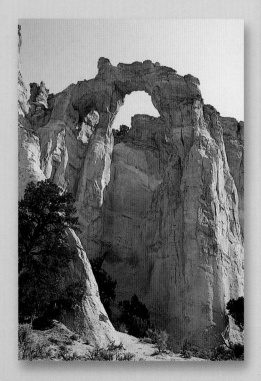

left ➤ **The Grand Staircase Escalante National Monument, Utah, US is a difficult and harsh environment to work in, but a rewarding one. Pentax 35mm kit.**

left ➤ **The picture shows a huge Fuji Crystal Archive print framed up. To stay sharp, you must shoot on Velvia 5x4in sheet film, using a view camera. Though big, this image is tack-sharp. Some printing processes can output digital SLR and 35mm images big, but they are not going to have anywhere near the quality you see with a view camera image.**

Creating a Web site

For really nice commercial sites for gallery prints, where first-class nature and landscape photographers market their work, take a look at the sites of Tom Mackie, Tom Till, and Jack Dykinga, at www.tommackie.com, www.tomtill.com, and www.dykinga.com, respectively. Look, too, at the Ansel Adams Gallery Web site at www.adamsgallery.com.

Using a commercial art gallery

There are also more professional ways to go about selling high-end gallery prints. My preferred method is to show work in a commercial photographic art gallery. This is probably the most professional way forward and also the most hassle-free route into print sales. The big advantage is that, in addition to the extra exposure your work receives, these venues tend to have better hanging space. In smaller venues such as cafés and bars, the display area is very limited. My prints can go really big, so it's a real bonus to have more room. The disadvantage with a gallery is that you normally have to pay up to 50 percent of the selling price to the venue. However, hiring out a room in a local venue for a few days to show off and sell work

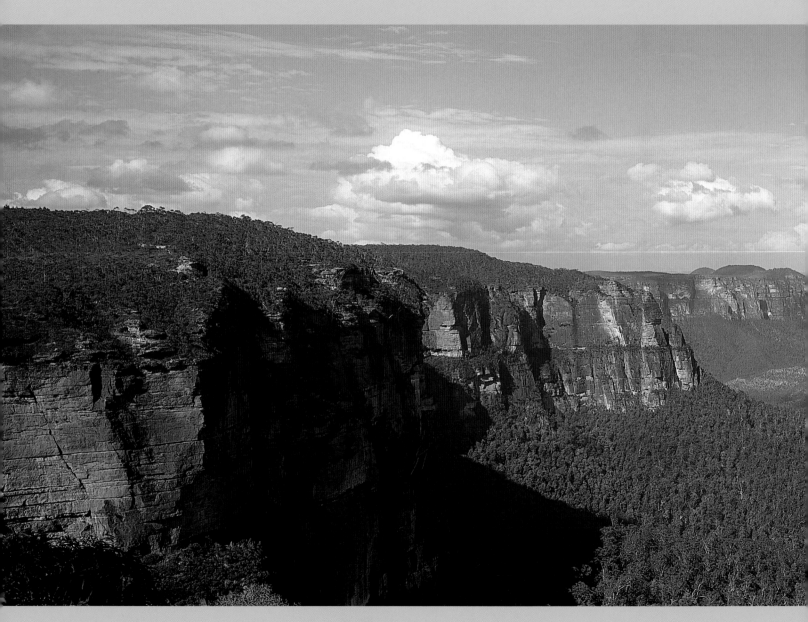

" When you consider all the thought, effort

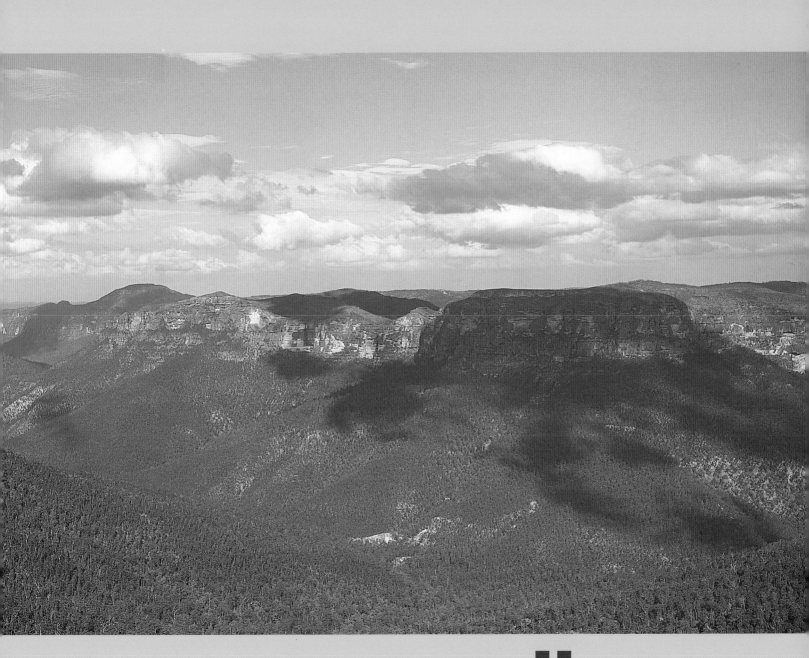

and cost involved, the price is not going to be cheap. **"**

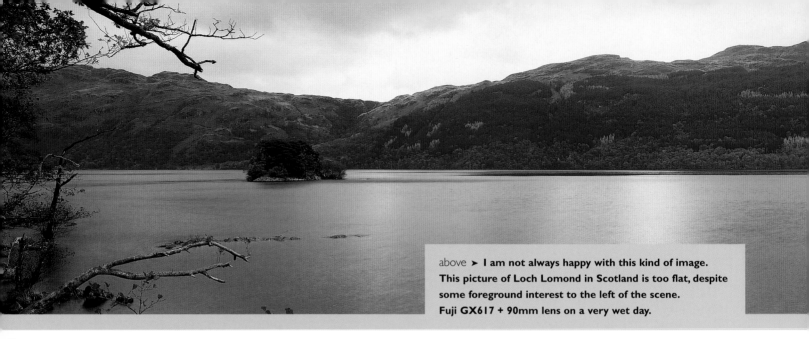

above ➤ **I am not always happy with this kind of image. This picture of Loch Lomond in Scotland is too flat, despite some foreground interest to the left of the scene. Fuji GX617 + 90mm lens on a very wet day.**

is logistically complex and quite time-consuming to plan. First, you have to put money into it up front, because you have to produce one-off prints from a large number of transparencies (sufficient to fill wall space), and all prints will incur additional mounting and framing costs. You will need to keep these on display throughout the exhibition, taking orders to fill only after the exhibition finishes. Success will only come if people know you are planning an exhibition, so add in any advertising costs.

In the US, nature and landscape photography is highly valued and big business. Many critically acclaimed—and virtual—galleries display and sell amazing works of art. Who can dispute the incomparable pristine natural beauty of the Western United States, influenced and perpetuated by the legacy of Ansel Adams? There are many wonderful photographers who follow in his footsteps and make a good living from selling their prints through galleries and on the Internet via their own Web sites.

Their work is so influential that they probably achieve more than many government organizations could hope to by dedicating themselves to promoting wilderness preservation. In the United States, people adore the landscapes produced by these artisans. They recognize their value, and are willing to pay a fair price for the work. In other parts of the world— the UK, for example—there are far fewer commercial galleries, and those that do exist tend to show contemporary photographic art, rather than the work of landscape and nature photographers. If you sell in the UK, you may find sourcing an outlet difficult. Perhaps things will change in the future. I am fortunate to have very sympathetic representation in the UK, and a lot of work goes into gallery prints, which I believe justifies the asking price.

below ➤ **Organ pipe cactus, Arizona, US Mamiya 711 + 65mm lens on Velvia, tripod. Shot in drizzle at 100 degrees.**

right ➤ **Few environments are as rich in life as this landscape at Yellow Waters Billabong, Kakadu National Park, Northern Territory, Australia. I tried to show the beauty of the landscape in this 6x7cm image taken from a croc-infested shoreline. Mamiya 711 + 43 lens on Velvia, tripod.**

below ➤ **Stainforth Force, River Ribble, Yorkshire Dales National Park, UK. Fuji GX617 panoramic camera + 90mm lens on Velvia, f/22½ at 2sec. The 90mm lens uses a matched concentric ND graduated filter (loses one stop). Without this spot grad, the bright torrent of water near the middle of the scene would have been considerably overexposed compared with the outer margins of the frame.**

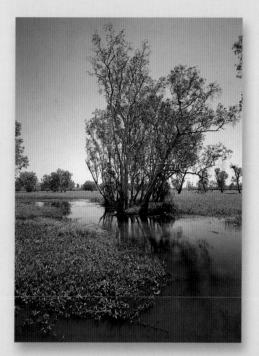

Ensuring top print quality

For clarity and tonal range, I shoot on medium, panoramic, and large-format transparencies, and 35mm for close-ups and action shots. When people buy one of my prints (see page 118), they are buying an original piece of art that will last a very long time. One can expect 60–70 years to elapse before any noticeable fade occurs—twice the archival life expectancy of Cibachromes. All my prints are framed in a distressed driftwood finish.

Just consider the costs involved: for a start, the gallery takes 50 percent of the selling price. Next, high-resolution scanning of an original transparency costs up to a hundred dollars or more if you use high-end drum scanners. High-quality output on Fuji Crystal Archive photographic paper means further investment. Then there's mounting, masking, and framing. You have all the petrol and time involved in dropping off and picking up trannies for

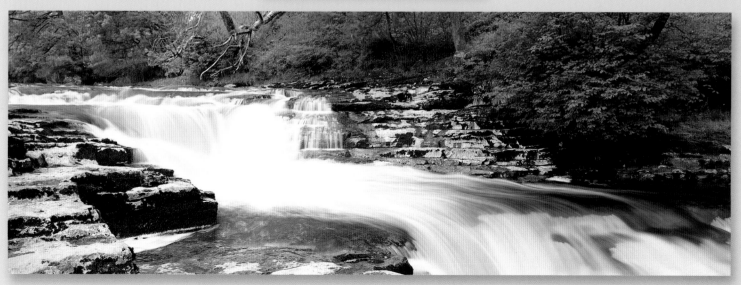

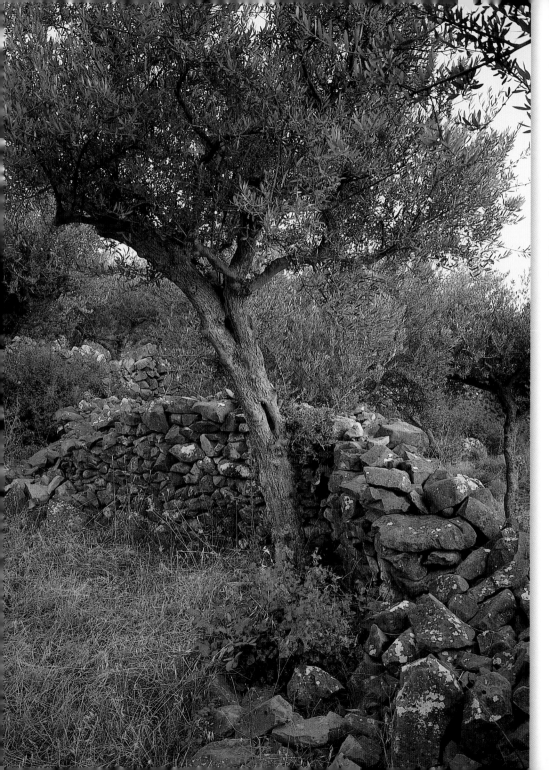

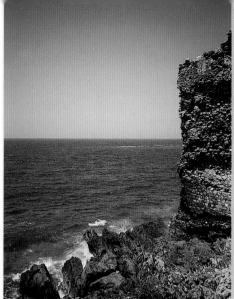

above ➤ **The rule of thirds has been applied in this interesting composition. I masked off the lower right-hand third of the frame with the rocky foreshore and ancient fortress wall respectively. If I had made either element impinge much more or less, the scene would not work so well. Fuji GA645Zi on Velvia, f/22.**

left ➤ **Taygetos Mountains, Greece. As dusk approaches in sunny locations, the light becomes warmer and softer. I used this to try to catch a view of an olive grove that would conjure up the Mediterranean ethos. At the same time, I wanted to produce a picture with some interesting detail and a harmony that would attract the viewer's attention for more than a fleeting moment. The old walling and equally old olive tree belong together. GA645Zi on Velvia, f/11 at 2sec.**

scanning, printing, mounting, masking, and framing—not to mention a special trip to sign the masks. It is easy to see how the costs build up to produce a large, professional-quality product. And that's without factoring in the cost of film, equipment, and travel in the first place.

Before you enlarge your work to large-sized prints, you have to select the right transparencies. First, if you want to retain knife-edge sharpness along with faithful colors, you need to consider only 6x12cm, 6x17cm, or 5x4in slides. The subject matter needs to be really special, too. The majority of slides I take look great in books and magazines, but would be totally inappropriate as gallery prints. You need to capture a place in such a way that the buyer wants to bring the essence of it into his or her home. Over a yard in size, a good image begins to transform—it isn't simply a picture, but a portal into a landscape.

Hung sympathetically, I like to think most of my gallery prints can transport you to the place where I first set up my tripod to shoot the scene. But remember, the best prints for obtaining this effect are always from big transparencies. 6x7cm is probably the smallest format you can go reasonably big with.

below ➤ **This view of the Sydney Harbour Bridge, Australia, was taken at just the right point between day and night. I shot several frames, but only this one had the right balance of color, and lack of hot spots from slow-moving boats. I used Velvia, which invariably gives a pleasing magenta cast to twilight images. This iconic urban vista was surely designed with panoramic photographers in mind. The final transparency has been drum-scanned at 300Mb resolution for 3x1ft output on Ilfochrome media. This perfect blend of film and digital technologies produces prints that can knock out an audience with their impact. The secret to this exposure was to spot meter off the far bridge tower, and bracket up (overexpose) by increments of half a stop. Fuji 6x17cm + 90mm lens, f/11 at 45 sec.**

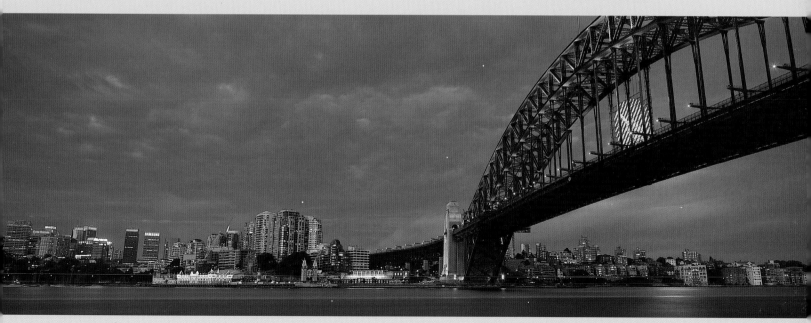

35A 36 ➡ 36A

Presentation

When you consider the effort and cost involved in producing a worthy print, it is clearly not necessarily going to be cheap. My preferred choice of frame is always driftwood because it complements the rustic nature of the images. Also, I have my prints bonded to the baseboard so they stay flat for ever. I don't recommend selecting cheap frames and taping them to the mount. The result will distort and warp over time. My frames are strung and come with all the fittings needed to hang the print properly. The choice is very much yours—many people stick to traditional materials like Cibachrome (Ilfochrome), while others use the latest generation of Epson ink-jet printer to produce archival-quality prints at home. I scan my original trannies at a professional bureau using a Fuji Lanovia scanner (maximum input 8000dpi). The scans are archived onto a CD and outputted onto archival-quality photographic paper without the intervention of interpolation software, using a Durst Epsilon printer.

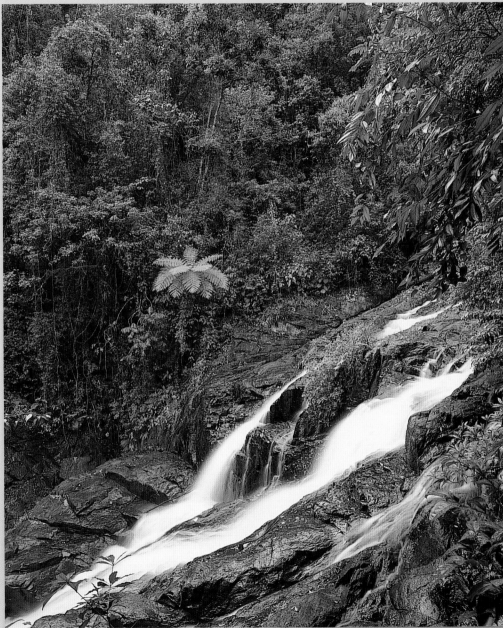

above ➤ **Bluebells in English woodland. Fuji GA645Zi on Velvia, f/22 at 2sec.**

Far left ➤ **Three Gossips, Arches National Park, Utah, US. Pentax MZn + 28–70mm zoom on Velvia.**

left ➤ **Lower Dinner Falls, Mount Hypipamee National Park, Queensland, Australia. Mamiya 711 + 43mm lens on Velvia.**

The scanning process

As with most things, many options are available when it comes to selecting a scanner to digitize your slides. Unfortunately, the pace of technology means that today's gold standard is rapidly being surpassed by tomorrow's innovations. Fortunately, quality is fast approaching the limits of what most photographers are ever likely to need.

If you work at home and demand the ultimate in quality, short of professional drum scans, the choice is either the Imacon Flextight range of scanners or slightly more affordable medium-format film scanners from Minolta, Nikon, and Polaroid. The Imacon range represents the highest quality available for professional desktop use, and can scan right up to 6x17cm panoramic format. The latest generation of Nikon scanner (Super Coolscan 8000ED) can almost match the quality of some of the Imacon range, but will only scan to 6x9cm. The Minolta Dimage Scan Multi-Pro is more affordable and almost matches the Nikon in terms of resolution for medium-format (6x9cm is the largest it can handle). The Nikon scans to 4000dpi (around 2.5ft^2 output at maximum input resolution for a 6x6cm tranny), with figures slightly less for medium-format scans on the Minolta (maximum input 3200dpi), and you need a good computer to throw these files around. In either case, file sizes around 200MB without interpolation are not unusual.

Your PC should have at least 1GB of RAM, and fast, preferably dual, processor chips. The hard disk would benefit from being a SCSI-controlled device with a fast rpm. You probably need a good Trinitron FST screen, FireWire connectivity, and the ability to archive large files. CDs and DVDs are today's medium of choice.

Pick your PC or Mac specs carefully so that your computer works well with your scanner using large files. Input resolution should be sufficient to output at 300dpi or more.

The more you pay, the better the scanner. There are many 35mm scanners, but few that can handle medium-format well. For the keen amateur or budget-conscious professional, the Nikon and Minolta or Polaroid Sprintscan 120 would be a good choice. Although the results from a flatbed do not match film scanners, as a panacea for all formats at a reasonable price, consider an Epson flatbed scanner, the first of a new generation of cheap but high quality flatbed scanners.

34A 35 ➡ 35A

DIY archival ink-jet prints

My first ink-jet printer outputted at 300dpi and the pictures were terrible. Today, I use 1440dpi output that is 100 percent photo-quality when I use glossy paper. One of the biggest issues with ink-jet printers is always the problem of color-fade and longevity; it isn't worth hanging an ink-jet picture on your wall if within a few months it fades away to a washed-out shadow of its former glory. Fortunately, the latest generation of Epson ink-jet printers solves this by employing archival pigment-based inks that claim to better good-quality photographic paper in terms of longevity. These printers can even output onto roll paper for full-width panoramic prints.

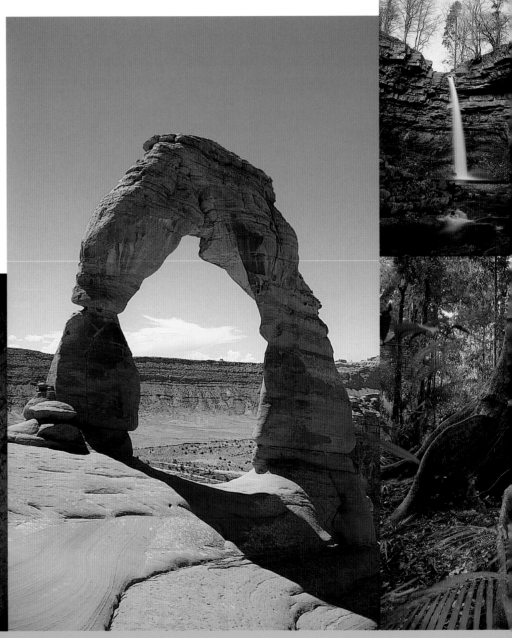

" A problem with ink-jet printers is color-fade

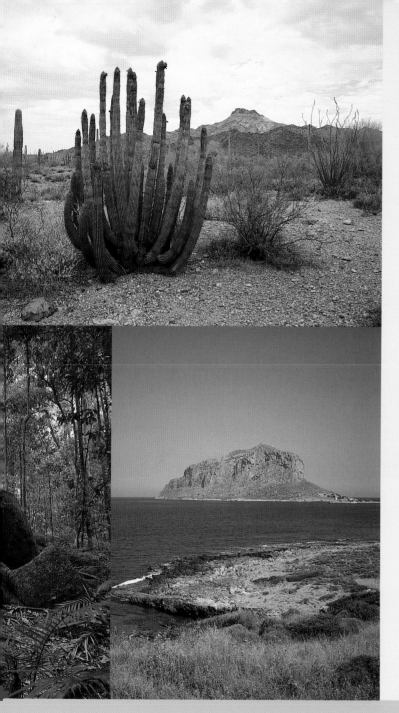

1 ➤ When traveling to new destinations, one way to find out what is worth shooting is to study the local postcards and then to put a new angle on a scene. This was literally the only angle worth shooting here. I took it handheld with my chin touching dirt. GA645Zi on Provia, f/22 at 7sec.

2 ➤ Delicate Arch, Arches National Park, Utah, US. Pentax MZn + 28–70mm zoom on Velvia.

3 ➤ Hardraw Force, Yorkshire Dales, UK. I used a wide-angle lens to take in the whole magical scene, included a bit of foreground interest, and avoided high-contrast light. In this case, it is the subject matter that makes this picture work, rather than the photographer's eye. Pentax 35mm kit.

4 ➤ Organ pipe cacti growing in the desert at Organ Pipe Cactus National Monument, Arizona, US. Deserts give you a good perspective on your place in the grand scheme of things. This shot is carefully orchestrated to show the reserve namesake in a wider desert context. Mamiya 711 + 65mm lens on Velvia, tripod.

5 ➤ I had seen a lot of postcards of Monemvasia, Greece, showing the Gibraltar-like rock sitting over the modern sprawl of the suburbs of this Laconian town. I dislike urban scenes, and therefore tried to exclude the influence of man, and searched around for a location where I could home in on the rock and sea alone. GA645Zi on Velvia, f/27 at 1/15sec.

6 ➤ Buttress roots on a rainforest giant. Shots like this have come to symbolize the rainforest, and engender the very spirit of the forest. I sell this as a framed print, and have one on my staircase wall. Mamiya 711 + 43mm lens on Velvia, tripod.

and longevity, but fortunately, quality is improving... ,,

Printing your work

Outputting from digital files can be a confusing area for those who are approaching it for the first time. Having got the best-quality scan possible from your transparency, you need to transcribe the digital bits and bytes you have archived onto a CD into the highest-quality output possible. In my opinion, the best route for this is to use Fuji Crystal Archive prints produced from master images, archived onto a convenient storage medium using fiber-optic LED or laser technology, exposing directly onto continuous tone photographic silver halide material. You should find that the resulting prints represent the ultimate in fidelity, color, clarity, and tonal range available on any photographic paper. Among the most popular mechanisms for producing photographic art in this way are LightJet, Chromira, and Durst printers. LightJet prints seem to be de rigeur in the US, where they are often used to produce high-quality landscape photographs.

Printing from slides

Optical reproduction onto Ciba/Ilfochrome paper is the classic way to produce prints from slides. The results can be truly amazing— indisputably "handmade" art. You need to be a master printer with specialized skills to make the most of this process, which is darkroom-based, and not digital. However, I don't like to send off an original slide in the mail when I want a print and, furthermore, results tend to be variable. I have seen good slides rendered poorly

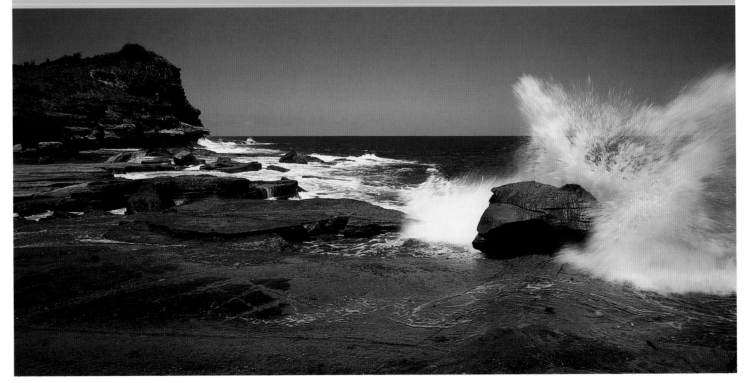

"Once digitized you need never worry about damage again..."

right ➤ **Unless you are a masochist, lightweight 35mm kit is the best medium to take on long hikes in remote, hot locations. This format accompanied me on a long hike to Widforss Point on the north rim of the Grand Canyon. I actually preferred some of the images that I took en route to those of the view at the trail's end. This shot was taken halfway along the trail, and is of one of the many tributary canyons that feed into the main chasm. The brightness and contrast conferred by the clouds meant that I had a lot of failed images, and so appreciated the economy of 35mm film over 120 or sheet film. Pentax MZ5n + 28mm on Velvia.**

left ➤ **Skillion, Terrigal, NSW, Australia. I decided to utilize the 6x12cm Horseman roll film back on my Ebony RSW and Schneider 80mm lens. This permits my other favored format—panoramic. f/22.5 at 15sec on Velvia 120 roll film. I swapped to this format as I thought the headland and surf-pounded rock provided the perfect counterbalance for an interesting panoramic scene.**

right ➤ **Beautiful British bluebells and fern. Sony Cybershot P72. I shot the fern as foreground interest.**

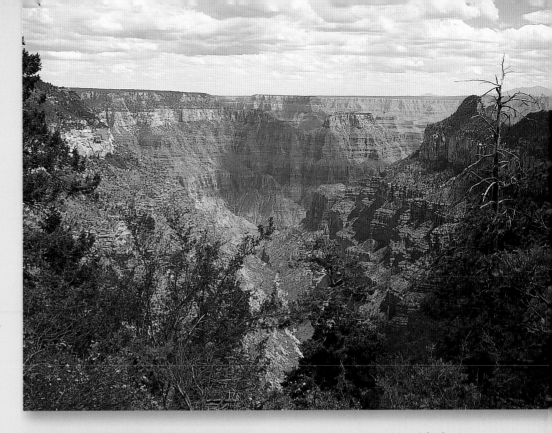

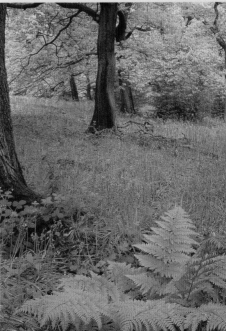

as well as brilliantly when printed. So, for me, digital output is preferable, as it is more controllable and more consistent in its results.

15A

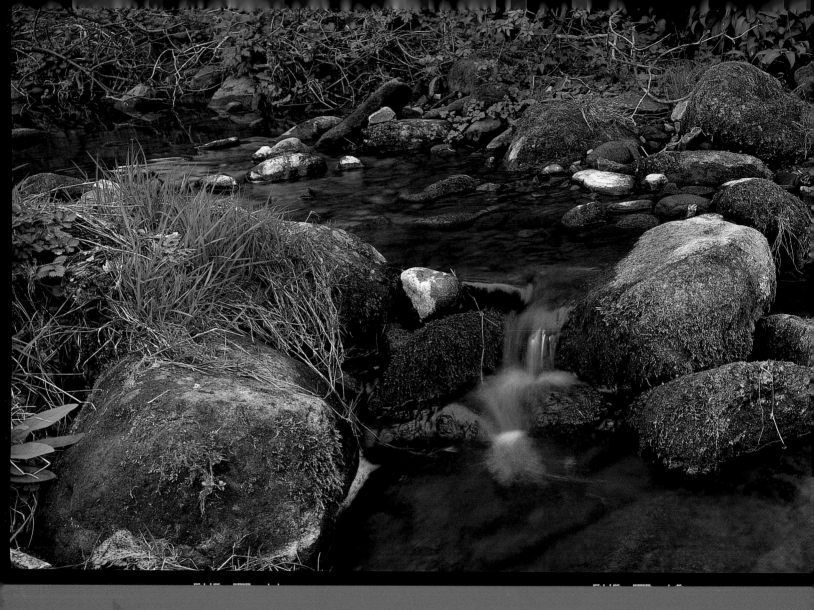

Appendix

" A good print transports the

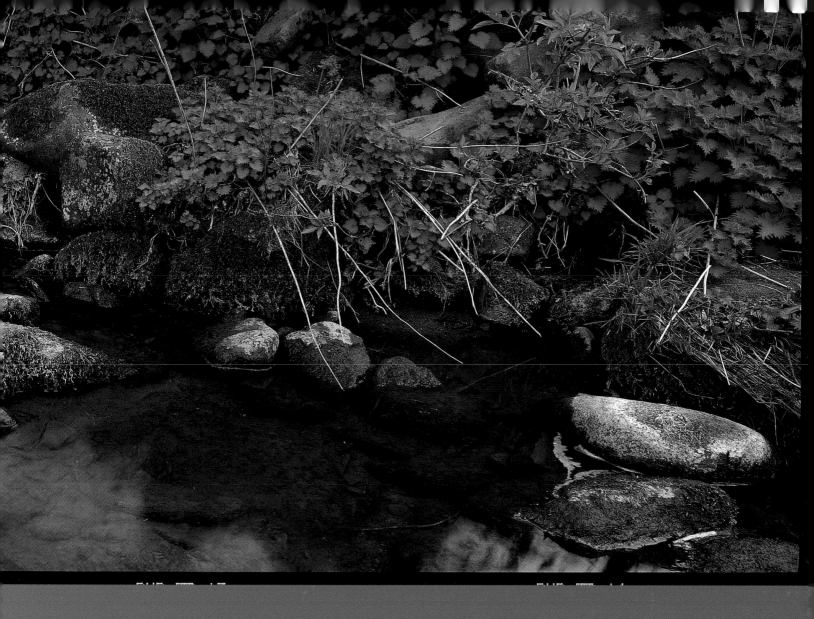

viewer to the original scene. "

Further sources of information

Useful Web sites

Sites that take you to the work of some of the world's greatest photographers

Alain Thomas Images
http://www.alainthomasimages.com/
Jack Dykinga http://www.dykinga.com/start.html
Jim Brandenburg
http://www.jimbrandenburg.com/home.html
Peter Lik http://www.peterlik.com/
Michael Fatali http://www.fatali.com/
David Muench http://muenchphotography.com/
Frans Lanting http://www.lanting.com/
Jim Zuckerman http://www.jimzuckerman.com/
Michael Hardeman
http://www.michaelhardeman.com/
Peter Dombrovskis
http://www.view.com.au/dombrovskis/index.html
Nick Rains http://www.nickrains.com/
Tom Till http://www.tomtill.com/
Gelen Rowell http://www.mountainlight.com/
William Neill http://www.williamneill.com/
David Ward http://www.davidwardphoto.co.uk/
Peter Adams http://www.padamsphoto.co.uk/
Tom Mackie http://www.tommackie.com/
Charlie Waite http://www.charliewaite.com/
Joe Cornish http://www.joecornish.com/
Heather Angel http://www.naturalvisions.co.uk/
David J Osborn
http://www.afterimagegallery.com/osbornnew.htm
Ken Duncan http://www.kenduncan.com/

Sites that offer photographic tuition

Light and Land http://www.lightandland.co.uk/

Bureaus for high-quality prints and E6 processing

CFL (Erina, NSW, Australia)
http://www.createdforlife.com/contact.htm
CC Imaging (Leeds, UK)
http://www.ccimaging.co.uk/

Web-based resources that review equipment and can address most contemporary photographic issues

The Luminous Landscape
http://www.luminous-landscape.com/
Digital Camera Product Reviews
http://www.dpreview.com/reviews/
Large-Format Photography (non-commercial community of large-format photographers, includes a repository of primers, how-to articles, users' reviews of equipment, and an active discussion forum.)
http://www.largeformatphotography.info/

Suppliers that I use for professional-quality equipment

Robert White (Poole, UK)
http://www.robertwhite.co.uk/index.htm
Dale Photographic (Leeds, UK)
http://www.shopcreator.com/mall/departmentpage.cfm?store=dalephotographic

Sites relating to camera equipment based on my own preferences

Ebony professional view cameras
http://www.ebonycamera.com/

Schneider optics
http://www.schneideroptics.com/
Rodenstock optics
http://www.rodenstockoptics.de/rodenstockoptics/index.htm
Mamiya http://www.mamiya.com/
Pentax http://www.pentax.co.uk/
Fuji http://www.fujifilm.co.uk/professional/index.html
Canon http://www.canon.com
Nikon http://www.nikon.com

Books

Charles Bowden, Jack Dykinga, *Jack Dykinga's Arizona*, Westcliffe Publishers 2004
Charles Bowden, Jack Dykinga, *The Sonoran Desert: Arizona, California, Mexico*, Harry N. Abrams, Inc. 1997
Janice Emily Bowers, Jack Dykinga, *Desert: The Mojave and Death Valley*, Harry N. Abrams, Inc. 1999
Robert Caputo, *Landscapes* (National Geographic Photography Field Guides), National Geographic Books 2002
Joe Cornish, *First Light: A Landscape Photographer's Art*, Argentum 2002
Ken Duncan, *Australia Wide—The Journey*, Ken Duncan Panographs 2002
Ken Duncan, *America Wide—In God We Trust*, Ken Duncan Panographs 2001
Jack Dykinga, *Stone Canyons of the Colorado Plateau*, Harry N. Abrams, Inc. 1996
Jack Dykinga, *Large-Format Nature Photography*, Amphoto 2001
John Fielder, *Colorado—Lost Places and Forgotten Words*, Westcliffe Publishers 1990

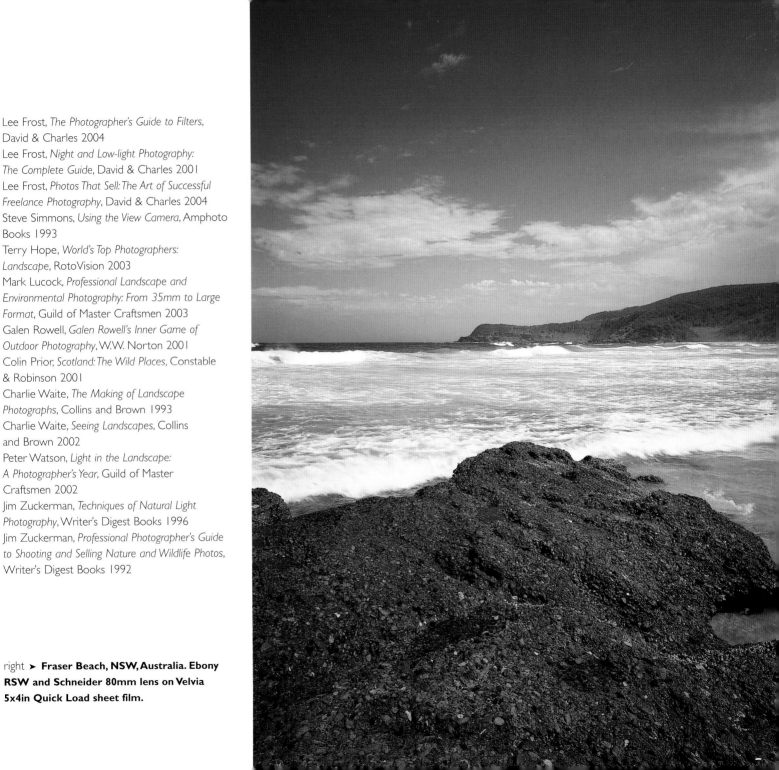

Lee Frost, *The Photographer's Guide to Filters*,
David & Charles 2004
Lee Frost, *Night and Low-light Photography:*
The Complete Guide, David & Charles 2001
Lee Frost, *Photos That Sell: The Art of Successful*
Freelance Photography, David & Charles 2004
Steve Simmons, *Using the View Camera*, Amphoto
Books 1993
Terry Hope, *World's Top Photographers:*
Landscape, RotoVision 2003
Mark Lucock, *Professional Landscape and*
Environmental Photography: From 35mm to Large
Format, Guild of Master Craftsmen 2003
Galen Rowell, *Galen Rowell's Inner Game of*
Outdoor Photography, W.W. Norton 2001
Colin Prior, *Scotland: The Wild Places*, Constable
& Robinson 2001
Charlie Waite, *The Making of Landscape*
Photographs, Collins and Brown 1993
Charlie Waite, *Seeing Landscapes*, Collins
and Brown 2002
Peter Watson, *Light in the Landscape:*
A Photographer's Year, Guild of Master
Craftsmen 2002
Jim Zuckerman, *Techniques of Natural Light*
Photography, Writer's Digest Books 1996
Jim Zuckerman, *Professional Photographer's Guide*
to Shooting and Selling Nature and Wildlife Photos,
Writer's Digest Books 1992

right ➤ **Fraser Beach, NSW, Australia. Ebony
RSW and Schneider 80mm lens on Velvia
5x4in Quick Load sheet film.**

Acknowledgments

For most photographers, the inspiration it takes to write about and shoot our planet's natural and man-made landscapes is undoubtedly tempered by many factors. Although achieving a spiritual oneness with nature is a major force for many of us, there are few who are not all the happier in their pursuits when they share their experience with a loved one. Thus, for me, a major factor in the production of this book and its images has been the constant support and encouragement offered by my wife, Jill.

I would also like to acknowledge the professionalism, expertise, and support provided by my editor for this project at RotoVision— Kylie Johnston. Her skills have made the production of this book a smooth process, no small task given my emigration to Australia halfway through its production (perhaps a small acknowledgment for the inventors of email is therefore also warranted).

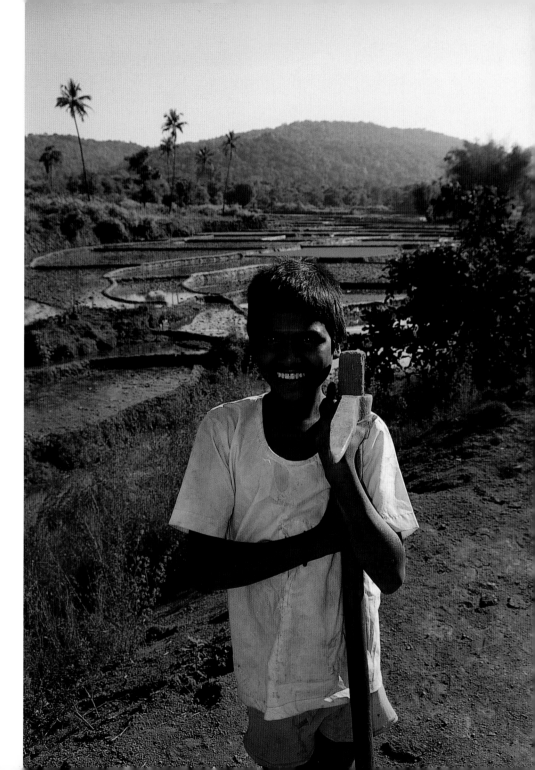

right ➤ **Child, paddy fields, rural Goa, India. The landscape takes on another dimension when you add a human element. In this case, the boy with his pickaxe dominates the scene. As he did not speak English, and I did not speak his language, I couldn't say whether he was working in the amazingly scenic paddy fields. The image, however, tells the viewer that he was. Shot on Velvia with a Pentax SLR handheld.**

Index